BASIC 35mm PHOTO GUIDE

for beginning photographers

Craig Alesse

AMHERST MEDIA, INC. ■ BUFFALO, NEW YORK

ACKNOWLEDGMENTS

I would like to thank the following people for their support and assistance in writing this book. First of all my family; my sister, Beth Alesse, for generously modeling for most of the photographs and providing guidance, encouragement and her graphic expertise; my mother, Betty Alesse, for her non-stop support, guidance, proof-reading, and graphic direction; my father, Thomas Alesse, for ideas which sparked this book and for his inspired direction; my brothers, Bruce, Matt, and Daniel for appearing in many of the photographs and for proofreading guidance; my aunt, Sally Casey, for aiding in the final proofreading; my grandmother, Zita Alesse, for modeling her great smile and providing inspiration and support; and my uncle, Don Alesse, for providing encouragement by periodically asking "Craig, is your book ready yet?"

I would like to especially thank Steve Mangione of State University College at Buffalo and Barry Evans of Focus-Pocus in Williamsville, NY for their careful proofreading and expert photographic guidance.

Thank you to Regina Campbell, Mary Ann Vathy, and Tony Bonanducci for their thoughtful proofreading and advice.

A special thanks to Bruce Bidwell for providing a needed sounding board and for his encouragement.

Published by:
Amherst Media Inc.
P.O. Box 586
Buffalo, NY 14226
Fax: 716-874-4508

ISBN: 0-936262-51-6
Library of Congress Catalog Card Number: 97-070419
Printed and bound in the United States of America

a new easy to understand format....

Preface

The 35mm camera is very popular — millions are in use today and millions will be sold in the future. Reasons for their great appeal are many. They are easy to use, a variety of films, lenses and accessories are available, and they are capable of producing high quality photographs.

Nevertheless, many beginning photographers are confused when they first own a 35mm camera; all the numbers, levers and buttons, even with an automatic camera. Beginners often find that although they can operate their 35mm camera, they don't quite understand how it works.

Basic 35mm Photo Guide is written and designed for the beginning photographer who wants to fully understand his/her camera and who wants to produce quality photographs, not just snapshots. The book is written in a simplified step-by-step format using over 175 photographs. It introduces the beginner to the basics: how to hold the camera, proper loading, f-stops, shutter speeds, basic exposure, semi-automatic and automatic cameras, lenses, films, and accessories, flash photography, lighting and basic composition.

The format of the book is unique, a step-by-step approach, using photographs to teach about photography. Bold graphics have been used to emphasize important information, and high quality paper has been used for improved photographic reproduction as well as for continual reference. We recommend that you read the book in sequence. If there is information you already know then feel free to skip on to the next section. The chapter on basic exposure should be especially helpful to beginners. Read it carefully, and have your camera handy to refer to as you read.

Basic 35mm Photo Guide will help you grow as a photographer. We hope that what you learn will help you change from one who merely takes snapshots to a photographer creating high quality photographs.

You must know the **basics** — no matter how automatic your camera.

Contents

1 Introduction frames 1-9

2 How to Hold Your Camera frames 10-23

3 35mm Film frames 24-47

4 Loading and Unloading frames 48-65

5 Camera Adjustments frames 66-94

6 Basic Exposure frames 95-105

7 Semi-Automatic Cameras frames 106-116

8 Automatic 35mm Cameras frames 117-120

Contents

9 Lenses frames 121-134

10 Lens and Camera Care frames 135-141

11 Lens Accessories frames 142-146

12 Flash Photography frames 147-164

13 Available Light frames 165-170

14 Composition — the rules? frames 171-178

for Beginning Photographers

Index

Introduction

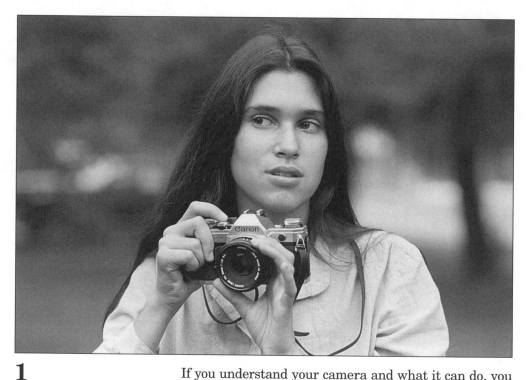

1

If you understand your camera and what it can do, you will take better photographs. This book is about basic 35mm photography: cameras and their adjustments, exposure control, lighting, composition, and using and taking care of your camera.

2

There are two types of 35mm cameras: the **lens-shutter** and **single-lens-reflex**.

This is a lens-shutter. It is sometimes called a rangefinder, compact 35 or "point and shoot" camera. It has various exposure controls and an automatic focus. Its viewfinder is through a window on top of the camera. The advantages of a lens-shutter 35mm are that it is very light, small and quiet to use.

3

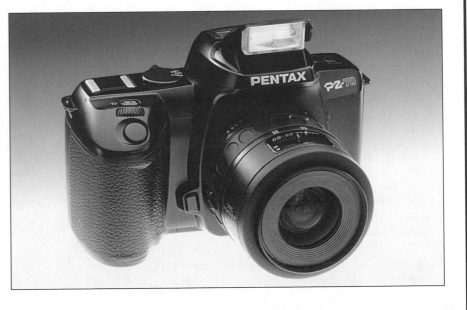

This is a single-lens-reflex or SLR. It has a unique viewfinder that allows you to look through the picture taking lens.

4

You see exactly what is photographed through a system of mirrors that reflect the image from the lens into the camera's viewfinder. This allows you to focus and compose your photograph very accurately.

5

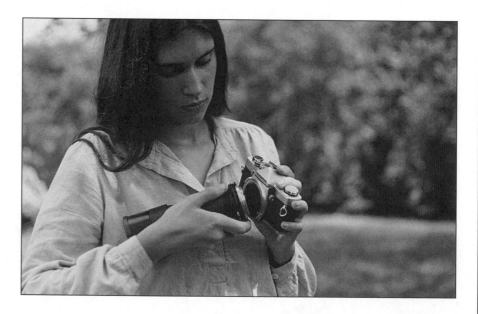

The SLR viewing system, therefore, allows you to put on telephoto, wide-angle, and zoom lenses and see through them. This is not possible with a rangefinder 35mm camera.

Both types of 35mm cameras have much in common; we will primarily discuss the SLR.

6

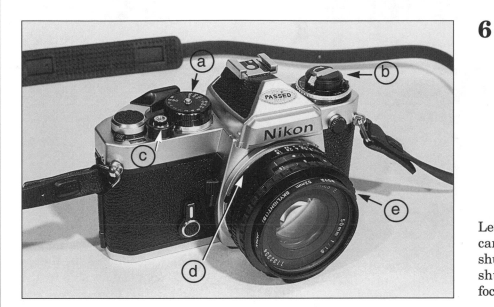

Let's take a look at the basic parts of a 35mm camera. From the front you can see the (a) shutter speed selector, (b) film rewind crank, (c) shutter release, (d) aperture ring, and (e) focusing ring.

7

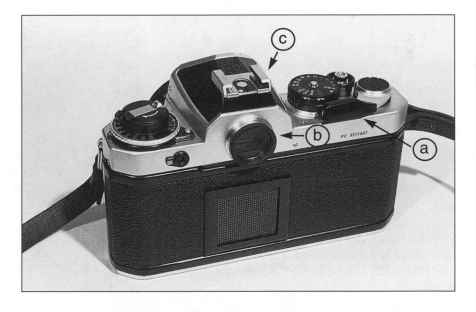

From the back of the camera you can see the (a) film advance lever, (b) viewfinder eyepiece, and (c) flash hot shoe.

8

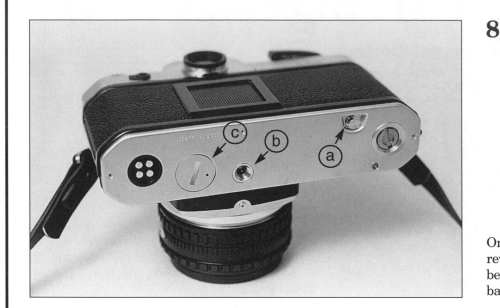

On the bottom of most cameras are (a) the film rewind release button, (which allows the film to be rewound) (b) tripod screw mount, and (c) the battery.

9

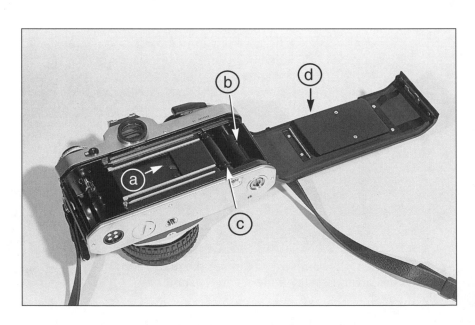

Inside you can see the (a) shutter, (b) take-up spool, (c) film sprockets, and (d) film pressure plate. Film is wound across the shutter, sprockets, and on to the take-up spool which is turned by the advance lever. After the pictures are taken, the film is rewound from the take-up spool back into the film cassette.

How to Hold Your Camera

Camera shake is a major problem when taking photographs; it results in unclear and sometimes blurred photos.

Hand holding is the most common and convenient way to use a camera. Most people cradle the camera body in their left hand and adjust the focus and exposure controls with their left fingers.

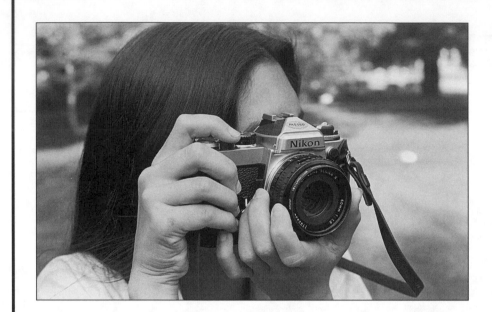

11

The right hand adjusts the shutter speed and the first finger releases the shutter.

12

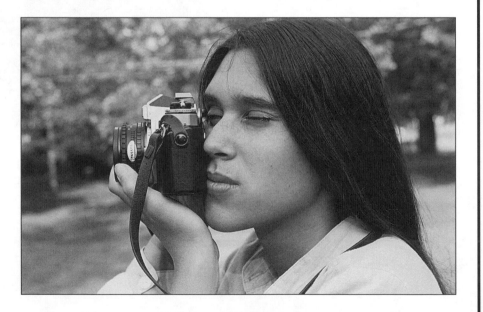

The camera is held firmly against the face to help stabilize each shot.

13

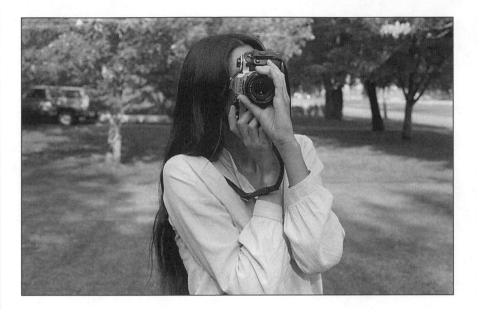

To shoot vertical photos, the camera is stabilized against the forehead and cradled in the left hand.

Many photographers find vertical photos appropriate when shooting portraits and vertical subjects.

14

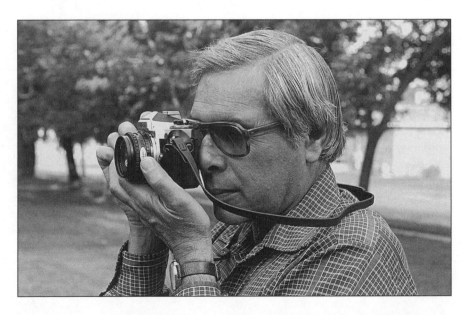

Eyeglasses pose a problem when taking photographs. It is difficult to hold a camera against your eyeglasses and keep the camera steady. Many photographers don't use their eyeglasses and instead buy a special corrective lens to put into the camera's viewfinder.

15

When you are standing to take a photo, plant your feet firmly on the ground and keep your elbows in to help keep balance.

16

As you are ready to release the shutter, exhale partially, hold your breath to stop movement and **squeeze the shutter smoothly.** Do not push it or you will move the camera and blur your photo. It is important to hold the camera as steady as possible!

Your may find it easier and more comfortable to hold your camera differently than we discussed. That's OK. The important thing to remember is that you must hold the camera secure so you don't move and blur your photos.

17

Experiment and practice hand holding and using your camera. You should feel comfortable and natural with it.

18

A creative photographer does not shoot all his photos from a standing position. It is a good idea to explore different angles and levels. Experiment in shifting your camera when you compose. Try shooting up at a subject or framing a subject with other objects.

19

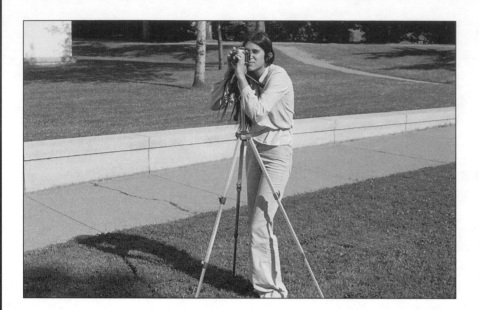

The best way to hold a camera steady is to use a tripod. It removes unwanted camera movement. A tripod allows you to use slower shutter speeds or to make time exposures of many seconds or minutes.

20

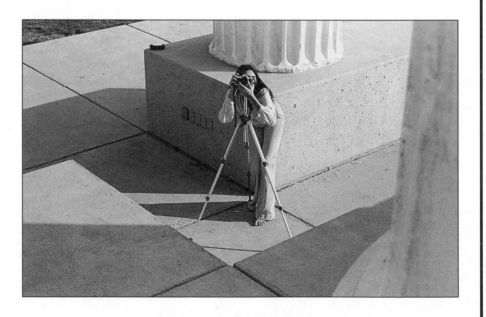

Tripods allow easier composition when photographing stationary non-moving objects such as still lifes and landscapes.

21

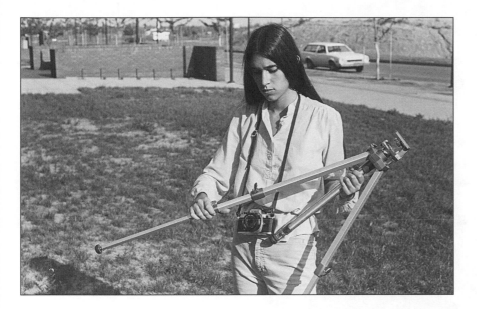

A tripod has several adjustments. Its legs can be adjusted to control height and

22

the camera can be tilted and panned horizontally.

23

A cable release can be used to minimize camera movement. It allows you to release the shutter without touching and possibly shaking the camera. Cable releases usually screw into the shutter button and they come in various lengths.

3

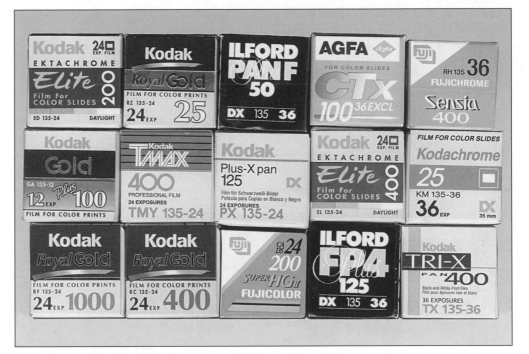

There are many types of 35mm film: black and white, color slide, color print, tungsten, etc. There are also numerous brands: Kodak, Ilford, Fuji, and Agfa among others. 35mm film gets its name because it is 35 millimeters wide. Most 35mm film is sold in lengths of 12, 20, 24, and 36 exposures.

25

All film is basically the same whether it is color or black and white. It is a thin plastic, coated with light-sensitive film emulsion.

26

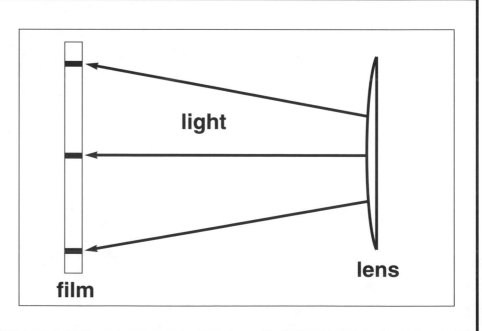

light

film

lens

When light comes through the lens and strikes the film emulsion, it turns dark in that spot. The brighter the light, or longer the length of time the light strikes the film, the darker the emulsion turns. These dark areas are called the latent image.

27

The image is then made visible when it's developed into a negative or slide (positive). The negative is then used to make a positive print. The slide (positive) is used for projection or printing.

28

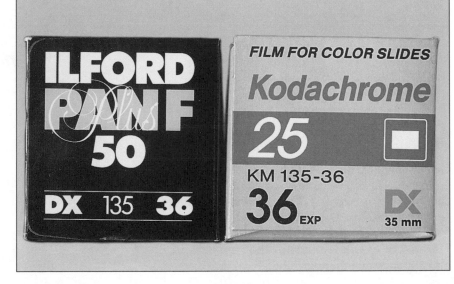

Each type of film has its own sensitivity to light. Films that are not very sensitive to light are called **low speed or slow films.**

These are two examples of low speed or slow film.

29

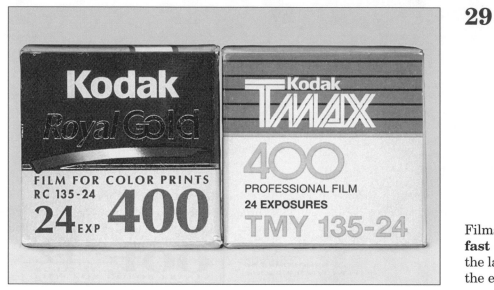

Films that are very sensitive to light are called **fast or high speed films.** The faster the film, the larger the light sensitive bromide crystals on the emulsion. This is called grain.

30

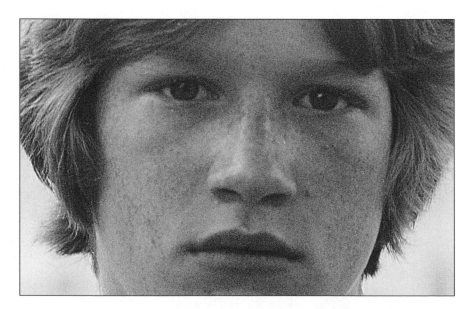

Grain can appear in some prints especially if enlarged. The slower and less sensitive the film, the finer the grain. The faster and more sensitive the film, the larger the grain.

Here is an example of grain that appears in a greatly enlarged photograph.

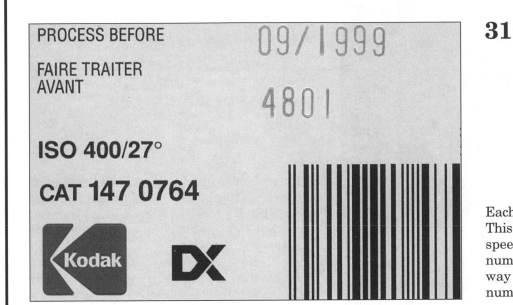

31

PROCESS BEFORE

FAIRE TRAITER
AVANT

09/1999

4801

ISO 400/27°

CAT 147 0764

Kodak DX

Each type of film has its own sensitivity to light. This sensitivity is rated by **film speed**. The film speed is indicated by either an ISO or ASA number. These numbers are expressed the same way and mean the same thing. The higher the number, the more sensitive and faster the film.

32

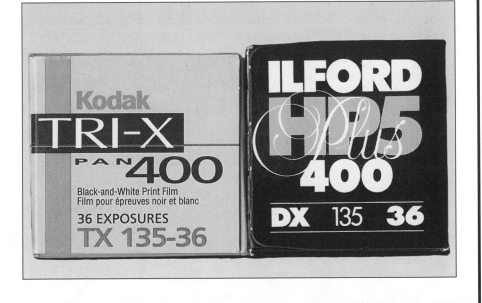

There are several common films.

Kodak's Tri-X and Ilford's HP 5 are black and white films with a film speed of 400. Both are fast, sensitive films.

33

They can be used under normal available room light without a flash. Fast films are the most popular black and white films because they can easily be used in either low or bright lighting conditions.

A main disadvantage is that fast films are grainy especially when greatly enlarged.

34

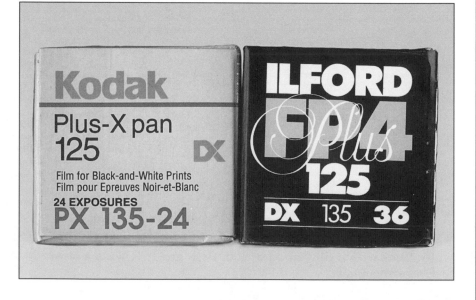

Kodak's Plus-X and Ilford's FP 4 are black and white films with a film speed of 125; both are medium speed films.

35

Medium speed films are not as sensitive as fast films and therefore not as grainy. They produce clear and relatively grainless enlarged prints. However, medium speed films require more light than fast films and must be used outside or inside with lights or a flash.

36

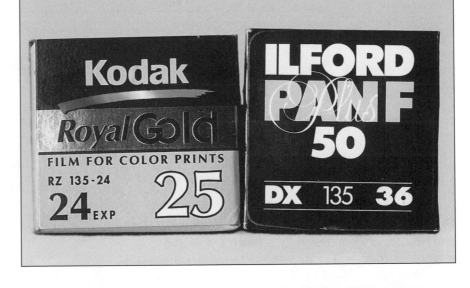

Kodak's Royal Gold 25 has a film speed of 25; Ilford's Pan F has a film speed of 50. Both are slow speed films. Each has very fine grain and produce clear enlarged prints.

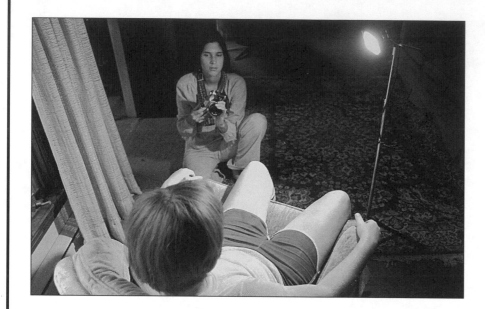

37

Slow speed films are usually used outside under bright sunlight or inside with extra lights or a flash.

38

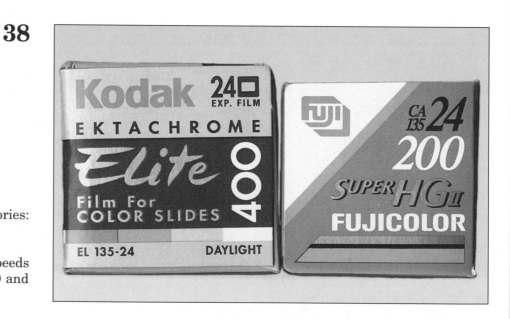

Color film is available in two main categories: print film and slide film.

It is also available in a variety of film speeds ranging from 25 to the very sensitive 400 and super-fast 1600.

color film

39

Color print film is processed into color negatives and then printed on photographic paper.

40

Color slide film is processed directly into positive slides. Prints can be made from these slides.

41

Slides are usually projected and many times are made into slide shows.

A "rule of thumb" for distinguishing between color slide and print film: Kodachrome and Ektachrome or film that ends in the word "chrome" is a slide film. Kodacolor and Fujicolor or film that ends in the word "color" is for color prints.

42

Color film also comes in either daylight or tungsten film. Each type has special color dyes to match for sunlight (daylight) or artificial light (tungsten).

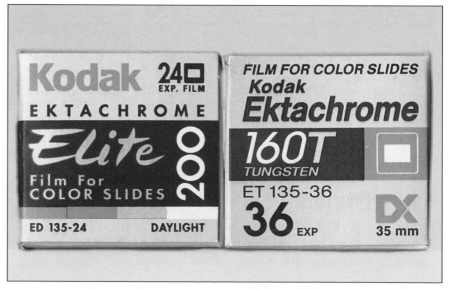

43

Selecting a film for your needs comes from experimenting with different types. Each type has its unique grain, contrast, and color qualities.

44

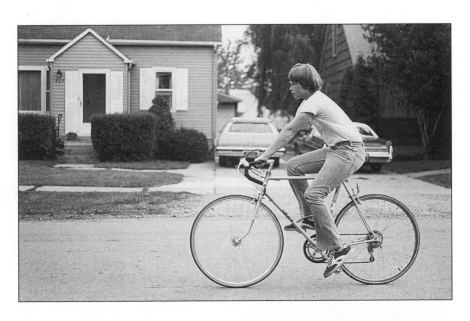

However, there are guidelines that will help you select the right film: film speed and grain.

Film speed. Are you shooting in low light? Are you shooting fast moving subjects that you want to freeze on film? If so, you may want to select a sensitive, fast film such as black and white Tri-X or Ektachrome 200, Ektachrome 400, and Kodacolor 400. Remember, these films are very sensitive and will appear a bit grainy if enlarged.

45

Grain. Are you shooting subjects such as portraits or landscapes where you want clear, low grain enlarged prints or slides? If so, you may want to select a slow black and white film like Plus-X or Ilford Pan F. For color select Kodachrome 25, 64, or Kodacolor 100. These films have fine grain.

There are many other brands and types of film. Don't be afraid to experiment and find out which you like best.

46

When you buy film check the expiration date. It's important to use fresh dated film and to have your film processed as soon as possible after taking your photos. Also keep your film in a cool, dry place away from dust. Excessive heat or moisture can damage the emulsion and affect the colors.

If you plan on storing film for any long period of time, it is a good idea to keep it in its plastic container and stored in the refrigerator. The cool temperature will keep the film from aging and will help it last longer.

PROCESS BEFORE

FAIRE TRAITER AVANT

09/1999

4801

ISO 400/27°

CAT 147 0764

Kodak **DX**

47

The hot glove compartment of your car is a poor place to store your film and camera. The heat can damage the emulsion and affect the colors.

47b

Kodak has two black and white films called T-MAX 100 (film speed of 100) and T-MAX 400 (film speed of 400). Both films use T-grain silver halide crystals in their emulsions. This produces greater image sharpness and less noticeable grain.

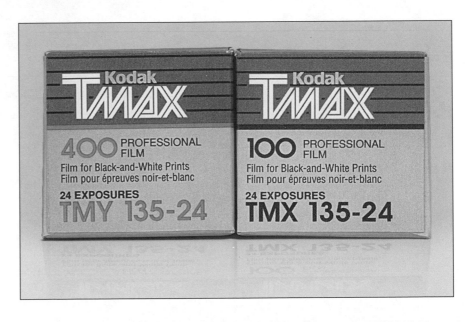

Loading and Unloading

4

48 When you are loading or unloading your camera, do it out of direct sunlight to avoid fogging the film. Make sure the camera is on a table or firmly held so you don't drop it.

49

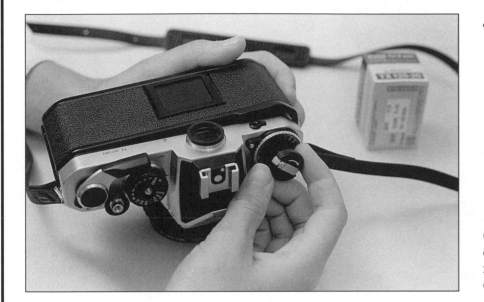

Open the camera back. This is done differently on various types of cameras. Some have a release lever; others open by pulling the rewind crank out all the way.

50

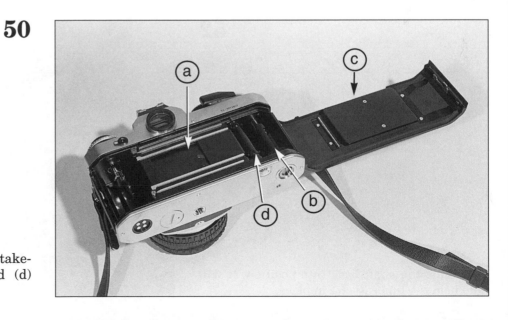

You can see the camera's (a) shutter, (b) take-up spool, (c) film pressure plate, and (d) sprockets.

51

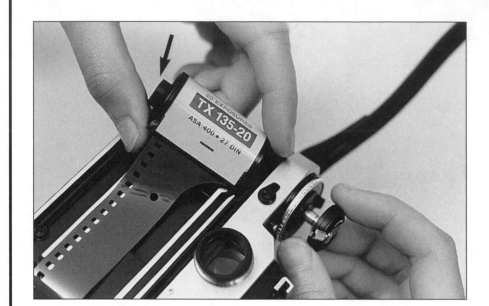

Pull the rewind crank out all the way and place the cassette into the camera. Make sure the cassette's tab (arrow) is facing the bottom of the camera.

52

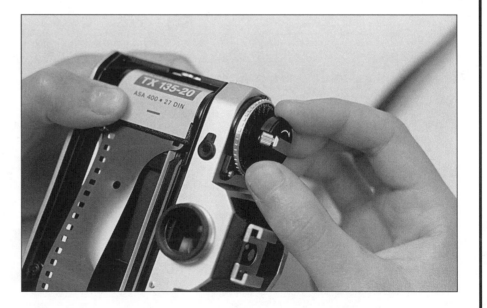

Now slide the shaft back into position. It will help hold the film cassette in place.

53

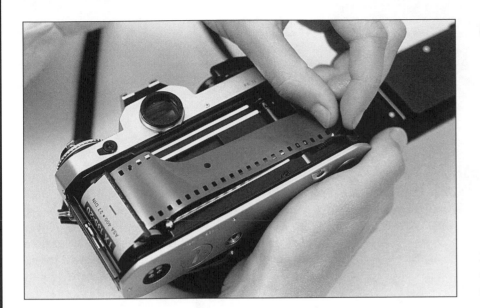

Pull the film leader out slightly from the cassette. Lay the film flat across the shutter and sprockets.

54

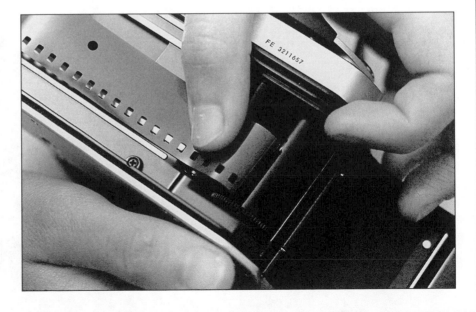

Slide the leader into the slot on the take-up spool.

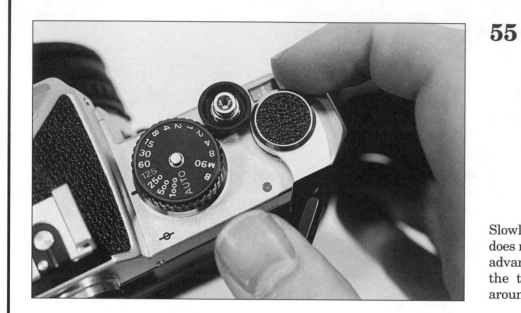

55

Slowly move the film advance lever (if the lever does not move, push the shutter button and then advance the lever). The advance lever will rotate the take-up spool and wind the film leader around it. Advance the lever until the...

56

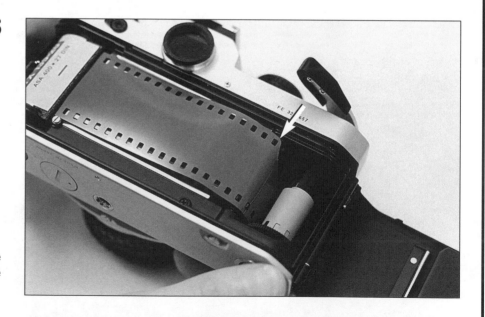

film is firmly around the spool and the sprockets engage (arrow) on both sides of the film.

engage on both sprockets

57

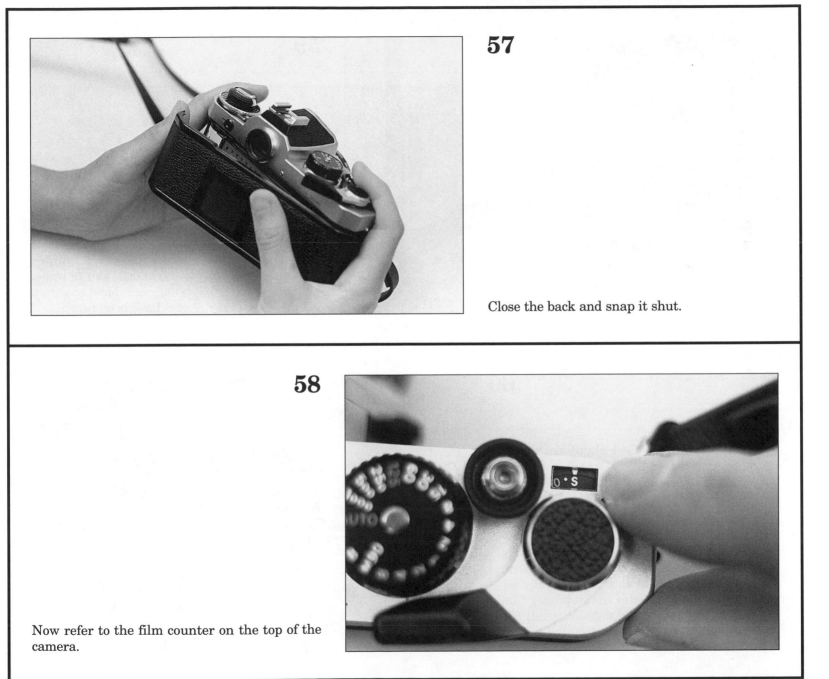

Close the back and snap it shut.

58

Now refer to the film counter on the top of the camera.

59

Advance the lever and release the shutter button several times until the frame counter moves to "0" (about two frames). You are now ready for your first photograph. Most counters indicate how many photos have been taken.

60

Before you take your first photo, set the film speed you are using. In this case we are using 400 speed film (arrow).

The latest cameras and films have **DX coding** (digital indexing). The film cassettes have a code printed on their side. When the film is placed into the camera, sensors read the code and automatically set the camera's light meter to the proper film speed setting. DX coding also can tell the camera how many frames are on the roll.

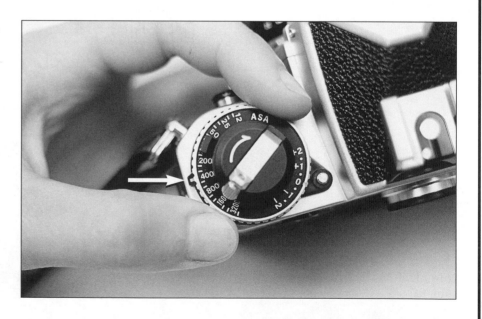

61

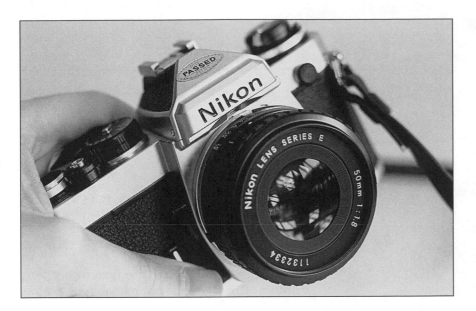

After you have taken the entire roll, you must rewind the film from the take-up spool back into the cassette. **Do not open the camera back until the film is rewound or you will expose the roll and ruin it.**

Make sure you only advance the film to the number of frames on your roll. For example, if you have a 20 exposure roll, take only 20 photos, no more. If you go past that number you could pull the film from the cassette and prevent the film from rewinding.

62

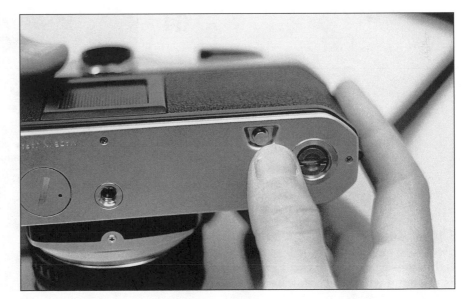

To rewind, push in the button on the bottom of the camera. Make sure it stays in.

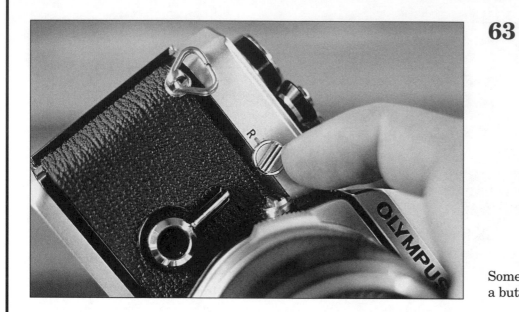

63

Some cameras have a knob to turn rather than a button. This Olympus has a knob type rewind.

64

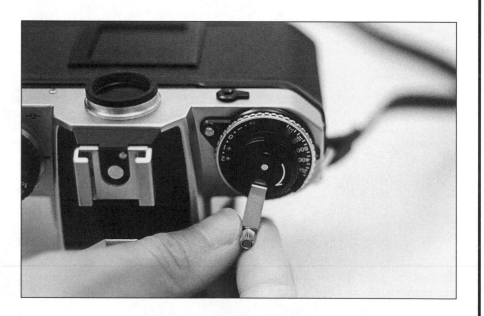

Unfold the rewind crank and turn it in a clockwise motion until the film is back inside the light-tight cassette. You will know that the film is rewound when the crank loses its resistance.

turn it clockwise

65

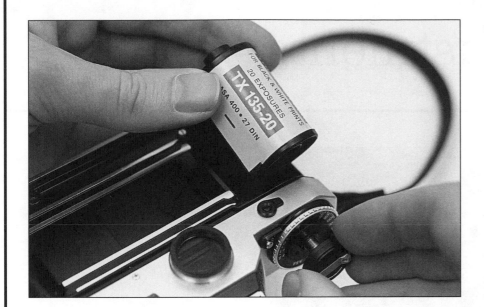

Once the film is rewound, open the camera back. Slide the rewind crank out, remove the film, and place it into its plastic container until processing.

65b

Many cameras, such as this one, have automatic film loading, motorized film advance and motorized film rewind.

Camera Adjustments

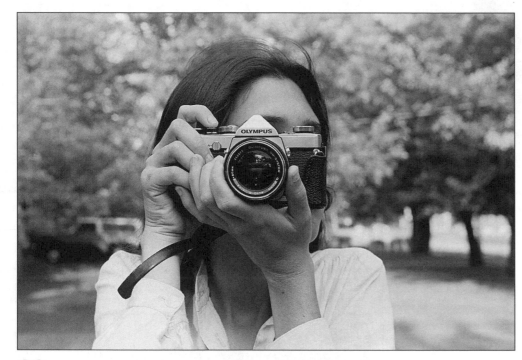

5

66

Most 35mm cameras have adjustments that enable them to take better photographs under a variety of light conditions. Some are adjusted manually with built-in light meters; these are called semi-automatic cameras.

67

Other 35mm cameras adjust exposure automatically; they only need to be focused. Most automatic 35mm cameras can also be operated manually for special conditions.

68

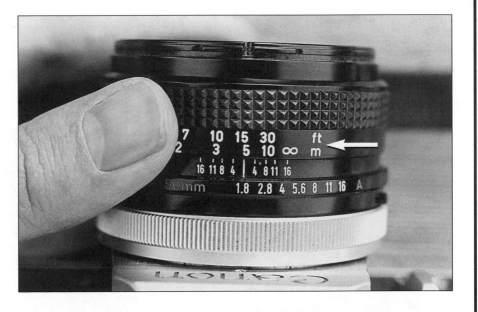

Focusing is done by turning the lens barrel. You can focus by setting the distance in feet or meters (arrow).

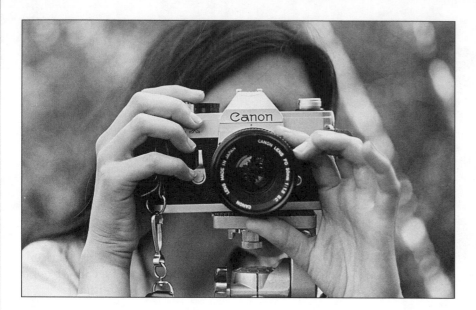

69

You can also adjust by looking through the viewfinder and turning the lens until the image is clear.

70

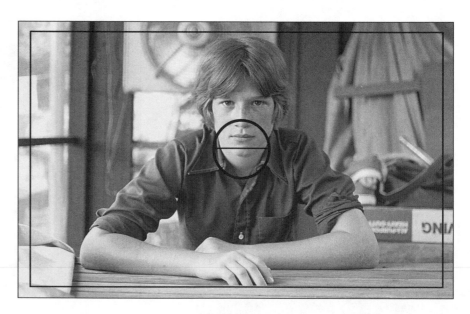

Cameras have different focusing screens to indicate a focused image. Some 35mm cameras have split image focusing. The lens is adjusted until two images in a circle line up.

split image

71

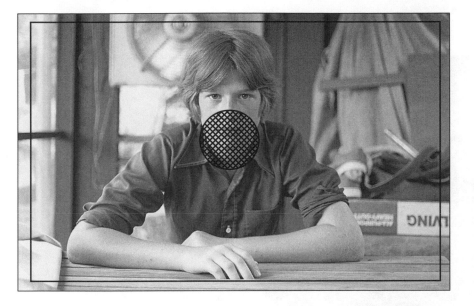

Others have grid focusing. The grid circle area is broken and unclear until adjusted to a clear focus.

Many 35mm cameras have interchangeable focusing screens. The screens can be changed for special uses.

72

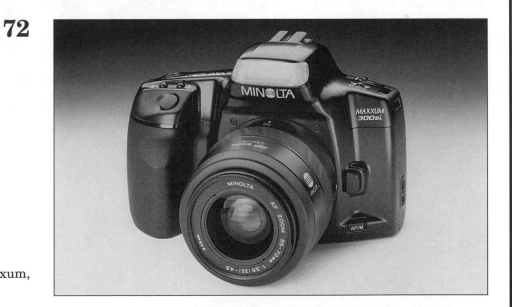

Some cameras, such as this Minolta Maxxum, have automatic focusing.

73

As discussed earlier, each type of 35mm film has its own sensitivity to light. This sensitivity is rated by an ISO or ASA number. Lighting conditions change depending upon where you take your photographs. Some conditions are low light such as in shaded areas.

74

Other conditions are very bright, such as in direct sun. To allow for proper film exposure, the amount of light must be controlled. This is called exposure control.

75

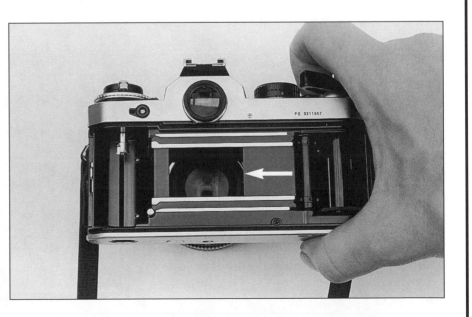

When the shutter button is released the shutter opens (arrow) for a preselected time, then closes. This exposes the film. The length of time the shutter is open is called the **shutter speed**. By increasing or decreasing the shutter speed you can control the length of time light will strike the film.

shutter speed

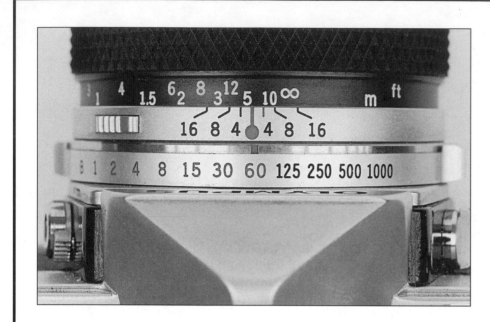

76

Most cameras have these shutter speeds: 1 sec., 1/2 sec., 1/4 sec., 1/8 sec., 1/15 sec., 1/30 sec., 1/60, 1/125, 1/250, 1/500, 1/1000. A **fast shutter speed** (1/1000) lets in **less** light. A **slow shutter speed** (1 sec.) lets in **more light**.

Many cameras also have a "B" setting on the shutter. When the shutter button is released with the camera on "B" the shutter will stay open as long as the button is held down. This is used for longer exposure times.

The shutter speed is usually indicated in one of two places: at the rear of the lens as on this Olympus,

77

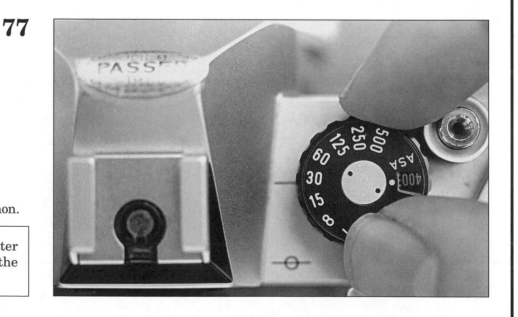

or on top of the camera body as on this Canon.

Many 35mm cameras indicate shutter speed when you look through the viewfinder.

78

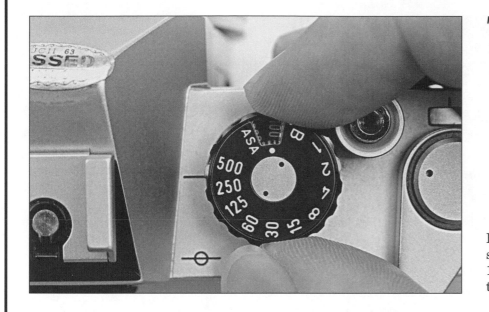

If you were adjusting your camera's shutter speed and decided to change from 1/250 sec. to 1/500 sec. you would double the speed, or cut the light in half.

79

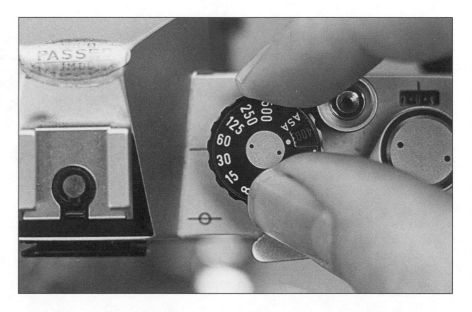

If you changed the speed from 1/60 to 1/30 you would slow the shutter speed and double the length of time light strikes the film.

80

Usually when the light is low, a slower shutter speed is used to let in more light. If the light is very bright, a faster shutter speed is used.

81

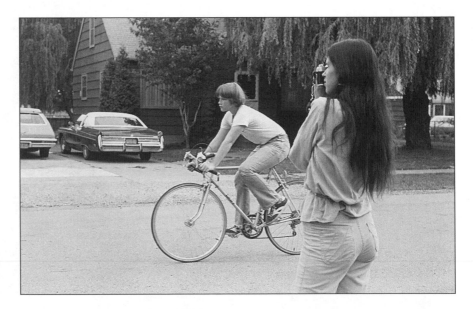

If you're photographing a subject ·that is moving, it's best to use a fast shutter because a fast shutter freezes action. Of course, if you wanted a blurred image to show movement, you would use a slow shutter speed.

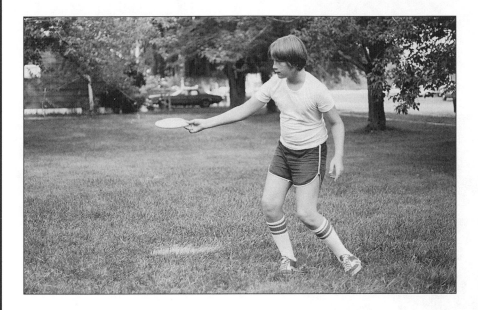

82

In this photograph a fast shutter speed of 1/1000 sec. was used. You can see the action is frozen.

83

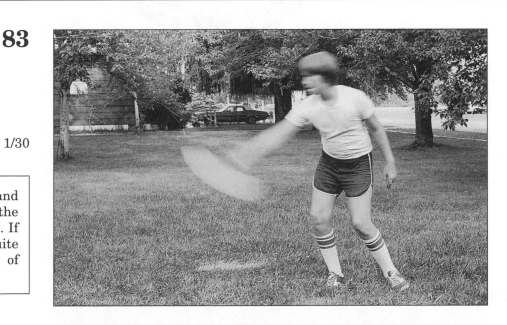

If a slow shutter speed is used such as 1/30 second, the action is blurred.

Usually, when a photographer is hand holding his camera, 1/30 sec. is the slowest shutter speed that can be used. If the shutter is slower, the image is quite often blurred by the body movement of the photographer.

84

Another way of controlling light is the **aperture**. It is located inside the lens and is an adjustable opening that controls the **amount** of light that goes through the lens and strikes the film. A large opening allows a lot of light to reach the film. A small opening allows very little light to reach the film. The aperture is sometimes called the lens opening, diaphragm, iris, or f-stop.

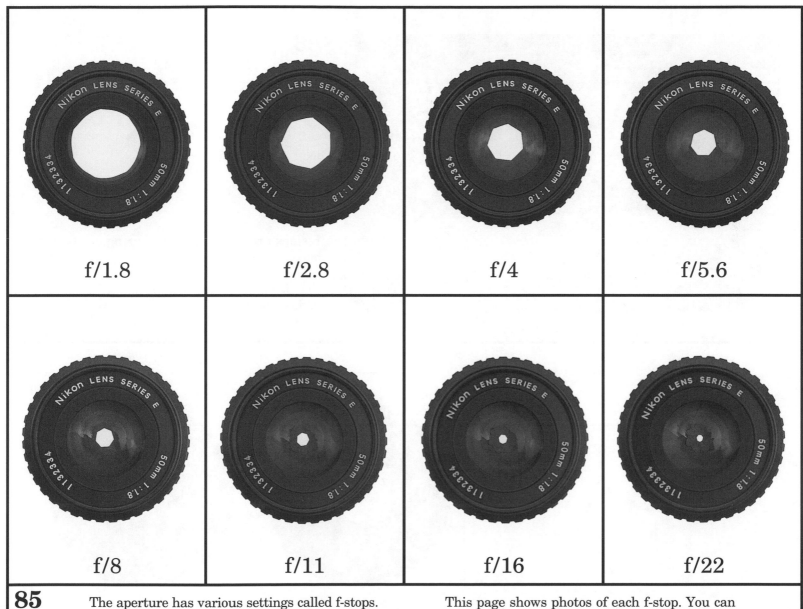

| f/1.8 | f/2.8 | f/4 | f/5.6 |
| f/8 | f/11 | f/16 | f/22 |

85 The aperture has various settings called f-stops. F-stops generally range from a setting of f/1.4 or f/1.8 the largest opening, to f/16 or f/22 the smaller opening.

This page shows photos of each f-stop. You can see how the size of the aperture opening change from setting to setting.

86

F-stops are set by a movable ring on the lens barrel.

This lens has an aperture range of f/1.8 to f/16 and is now set at f/8.

87

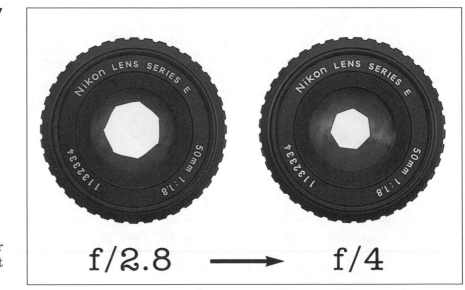

f/2.8 ⟶ f/4

Each time the aperture is made smaller, for example, from f/2.8 to f/4, the amount of light is cut exactly in half.

light is cut in half

88

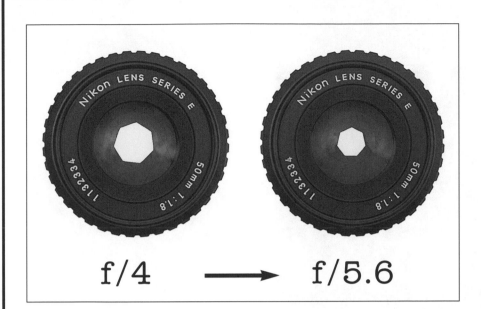

f/4 ———→ f/5.6

As the aperture is made smaller from f/4 to f/5.6, the light is again cut in half.

89

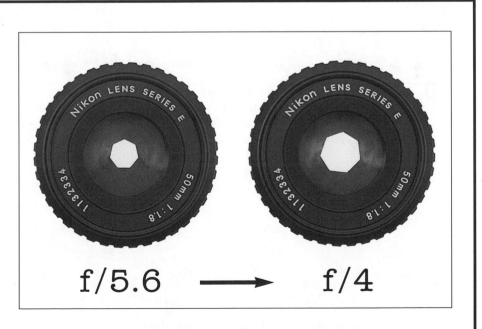

f/5.6 ———→ f/4

The reverse is true. Each time the aperture moves, for example, from f/5.6 to f/4, the light is doubled. This is true each time the aperture moves, from f/11 to f/8, from f/8 to f/5.6 and so on.

Each time the number changes, the light is either doubled or halved.

light is doubled

90

The aperture opening, in addition to controlling the amount of light passing through the lens, is one way of controlling **depth of field.** Depth of field is the distance or depth that appears in focus through the lens. The size of the aperture opening greatly affects the amount of depth of field.

91

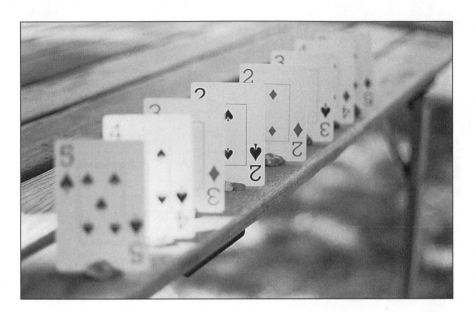

This photo shows a short depth of field. The lens is focused on the 2 of spades. The other cards are noticeably out of focus. The aperture setting used was f/1.8, a large aperture.

92

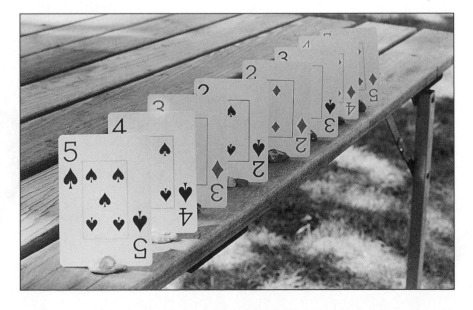

In this photo the depth of field includes all the cards, its aperture setting was f/16, a small aperture. In both photos, the lens was focused on the same point, the 2 of spades.

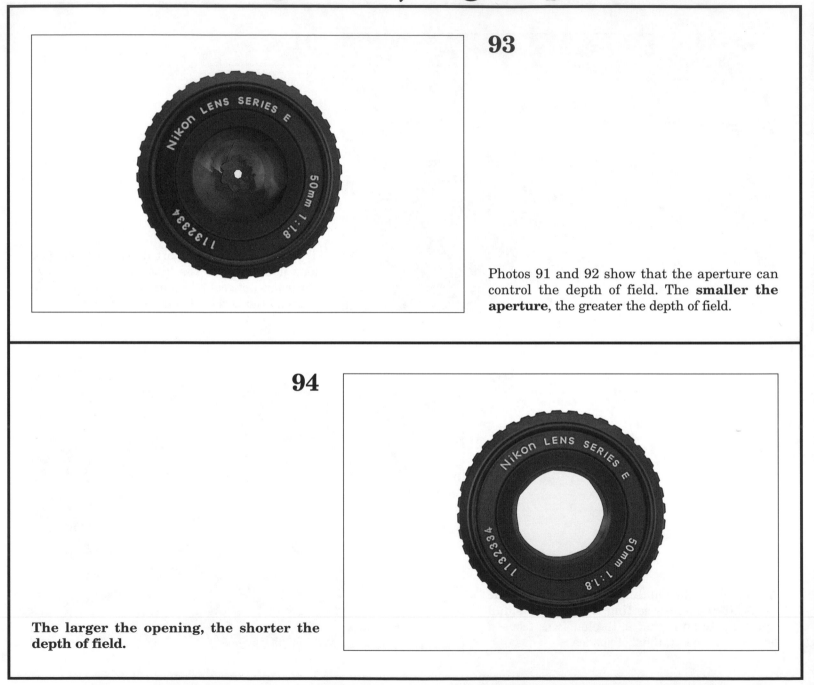

93

Photos 91 and 92 show that the aperture can control the depth of field. The **smaller the aperture**, the greater the depth of field.

94

The larger the opening, the shorter the depth of field.

Basic Exposure

6

There are many shutter speeds and aperture settings on a 35mm camera. To set them properly and get a perfect exposure, you must first measure the light.

96

There are several ways to measure light. One way is with a hand held light meter. Another way is with the built-in light meter in automatic or semi-automatic cameras.

97

Both meters are basically the same. However, let's take a look at a hand held light meter; if you understand how it works it will help you understand the built-in camera meter.

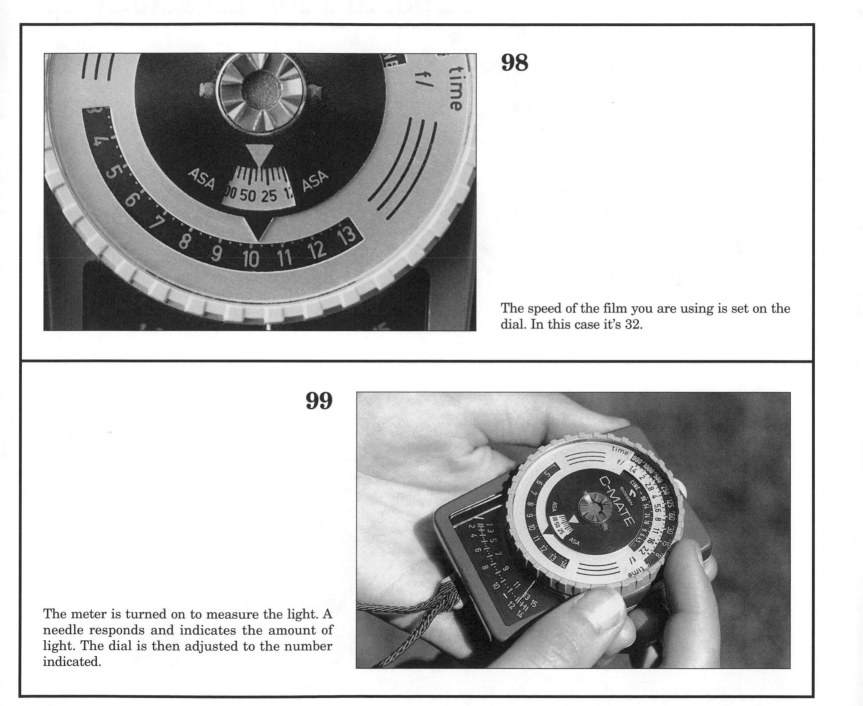

98

The speed of the film you are using is set on the dial. In this case it's 32.

99

The meter is turned on to measure the light. A needle responds and indicates the amount of light. The dial is then adjusted to the number indicated.

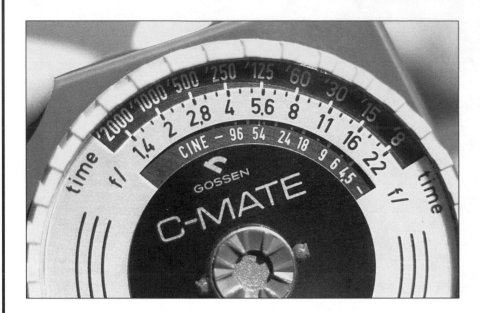

100

On the dial the shutter speeds are marked "time." Directly below are the f-stops (apertures).

The shutter speeds and f-stops line up to show the exposure combinations that can be set on the camera.

Any of the combinations that line up can be used, 1/60 and f/8, 1/125 and f/5.6, 1/1000 and f/2. Each combination on the dial would work and could be set on the camera to produce the same exposure on the film.

101

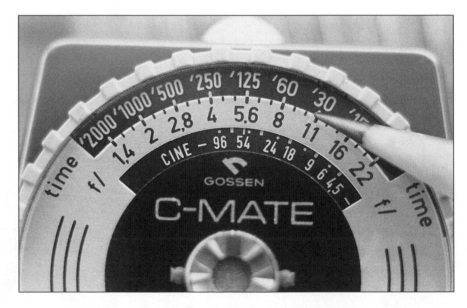

The difference among the combinations is that if depth of field is important, an exposure with a smaller aperture would be selected, such as 1/30 and f/11. This exposure would give a large depth of field. The limitation is that to have a large depth of field you would have a slower shutter (30) and cannot freeze action.

102

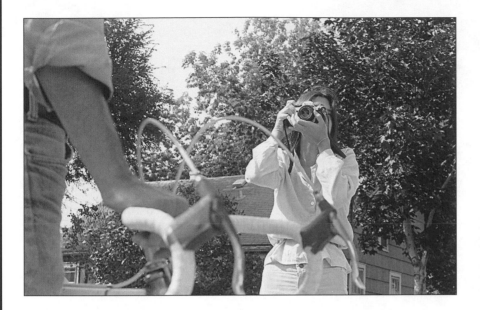

If a fast shutter was important to freeze action, you would select an exposure combination with a fast shutter speed such as 1/500 and f/2.8. However, you get a large f-stop and small depth of field.

103

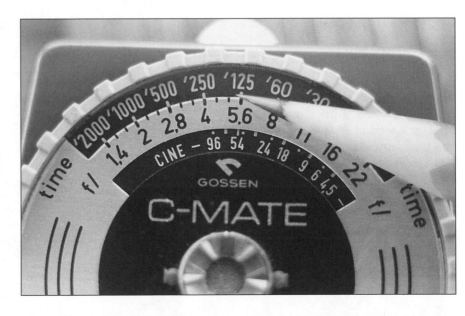

You may want to compromise and use a combination that has an acceptable speed and depth of field like 1/125 at f/5.6.

If you look at the exposure combinations, you'll notice that if you change from an exposure of 1/125 to 250, the light is cut in half. However, the aperture goes from 5.6 to 4 and doubles the light. One balances the other, keeping the exposure the same.

104

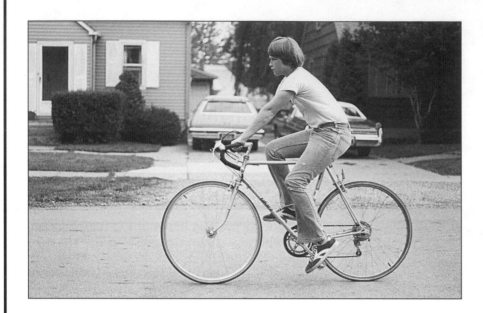

Here's an example of using two different exposure combinations. In this photo the f-stop is f/2, a large opening. The shutter speed is 1/1000 sec. The lens is focused on the bike rider and the house and car are unclear. The photo has a small depth of field.

105

In this photo the f-stop is f/8, a smaller opening; it has a greater depth of field. The shutter speed is 1/60 sec. The car and house in the background are clear and in focus as well as the foreground even though the lens is focused on the rider. The rider is blurred because a slower shutter speed had to be used to allow for a small aperture and a greater depth of field. If you want a large depth of field in your photo, you would make the aperture as small as possible. However, you then use a slower shutter speed and possibly get blurred movement.

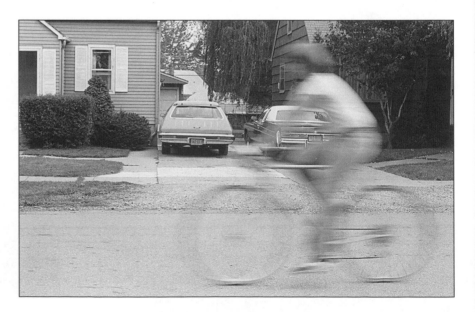

Semi-Automatic Cameras

7

Most 35mm cameras have built-in light meters, so a
hand held meter is not usually needed.

106

107

Modern built-in meters are through the lens, that is they measure the amount of light that comes through the camera's lens. This makes them very accurate.

108

This is especially helpful with a telephoto lens because you measure the light in your photograph from a distance and not just the light around your camera.

Using a built-in meter is a bit different from a hand held meter.

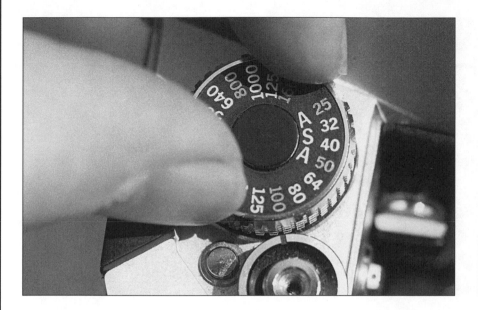

109

The first step in using a built-in meter is to adjust the camera's meter to the speed of the film you are using (referred to as ASA in the picture to the left). In this photo, the Olympus SLR is being adjusted to the film speed of 100 by adjusting a dial on top of the camera.

Remember, ISO and ASA are the same number and indicate the film's speed.

110

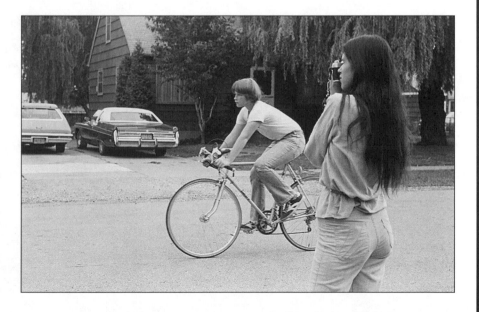

Next, you compose your photograph, then select a shutter speed. If you are outside and are photographing something moving, you would select a faster shutter speed like 1/500 sec. or 1/1000 sec.

111

If you are inside using available room light, you would usually select a slow shutter to let in more light. This depends on the type of film you are using.

Once the shutter is adjusted, you adjust the aperture.

112

With this camera's meter, this is done by matching two needles that appear in the viewfinder.

Some cameras use a bracket or light system rather than matching needles; all are basically the same.

113

If you turn the aperture ring, one of the needles can be moved until the two needles are in line. When they are in line, the aperture is at the proper setting.

114

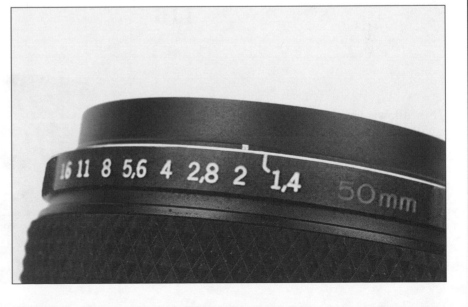

Once the needles are in line, you may find that the aperture is too large, and therefore the depth of field too small.

115

In this case select a slower shutter speed, if possible, and re-adjust the aperture by rematching the two needles.

116

This allows you to line the needles up at a smaller aperture and increase the depth of field.

Some photographers prefer to set the aperture of the camera first, and then match the needles by adjusting the shutter speed. This way they can pre-select the depth of field they want. Either technique discussed will work, the choice is up to the individual photographer and situation.

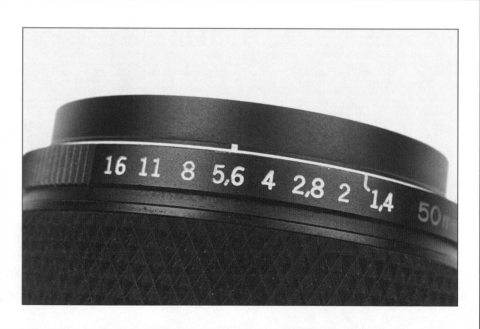

Automatic 35mm Cameras

8

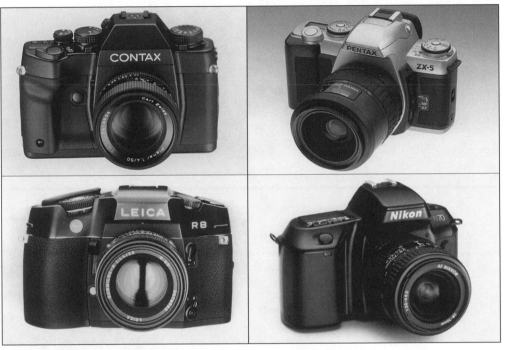

Automatic 35mm cameras have built-in exposure meters that adjust the shutter and aperture automatically. Some models have automatic focusing as well. The photographer simply composes his photo, focuses if necessary and releases the shutter. There are several types of 35mm automatics: aperture priority, shutter priority, aperture/shutter priority and program.

118

This camera has aperture priority. You set the camera aperture and the shutter adjusts automatically to the correct speed.

119

This camera has shutter priority. You select the shutter speed and the aperture adjusts automatically.

120

Some cameras have both aperture and shutter priority. You select which mode you want.

Many automatic 35mm cameras have a manual override which allows the camera to be operated manually for special needs and lighting conditions.

120b

Program a is common feature of automatic 35mm cameras. This mode sets both the shutter and aperture automatically.

Some program 35mm cameras such as this one have **tele program** and **wide program** settings as well. The tele program setting automatically selects faster shutter speeds to freeze action. This feature is sometimes referred to as "action setting" or "high speed program" depending on the camera.

The wide program setting is also automatic and selects smaller aperture settings rather than faster shutter speeds. This produces photos with greater depth of field. It is sometimes called the "creative setting" or other names depending on the camera.

Cameras that have the program, tele-program and wide program features together are commonly referred to as **multi-program** cameras.

Lenses

9

121 Most 35mm single lens reflex cameras allow for interchangeable lenses. This way different lenses with different focal lengths can be used. Focal length determines the field of view a lens sees.

122

Lenses are categorized by focal length and are measured in millimeters. The focal length and the largest aperture of the lens are usually marked on the front of the lens.

The most commonly purchased lens is a **normal lens**. Its focal length is about 50mm. A normal lens is popular because it has about the same perspective as the human eye.

123

One group of lenses are wide-angle lenses. Their focal lengths include all the lenses less than 50mm. A common wide-angle lens is 28mm like the one shown here.

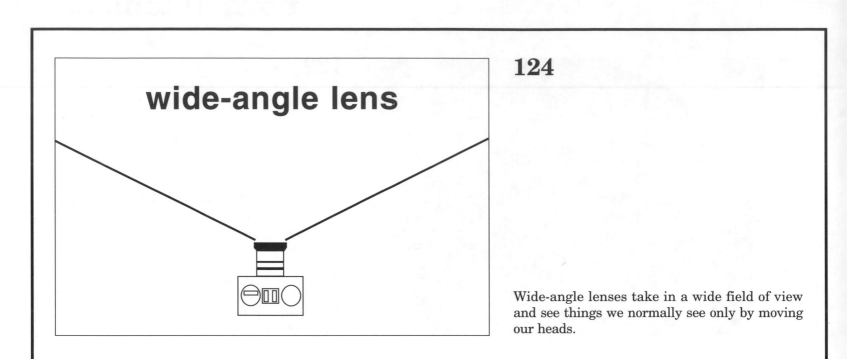

wide-angle lens

124

Wide-angle lenses take in a wide field of view and see things we normally see only by moving our heads.

125

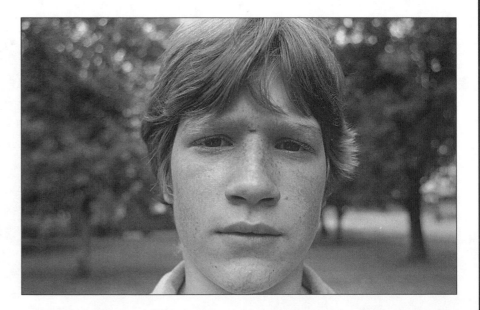

Wide-angles usually make things appear bigger and distort images if they get close to their subject.

126

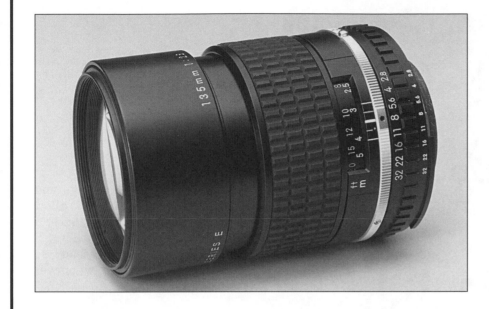

Telephoto lenses range from about 60mm to 1000mm. The most common telephoto lens is about 135mm.

127

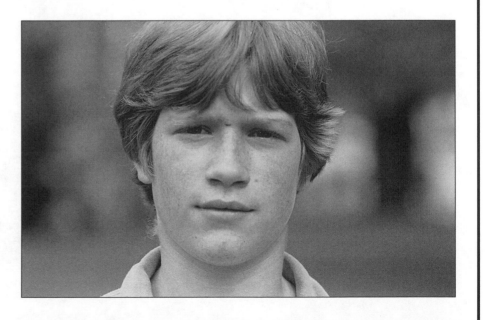

Telephotos have a narrow field of view. They see things we could see only by getting closer to our subject, much like a telescope. Telephotos have the illusion of flattening images, especially when compared to wide angle lenses as in photo 125.

128

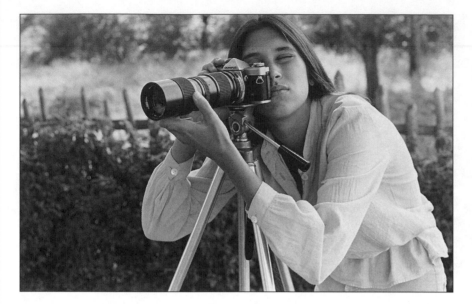

Larger telephotos are popular for sports and nature photography because they allow photographers to take photos from a distance.

Telephotos are difficult to hand hold steady, so it is a good idea to use a tripod whenever possible.

129

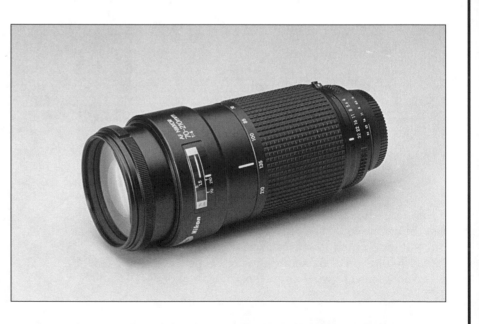

Zoom lenses are special lenses that can adjust in a variety of focal lengths. They are available in various sizes. This one ranges from 70mm to 210mm.

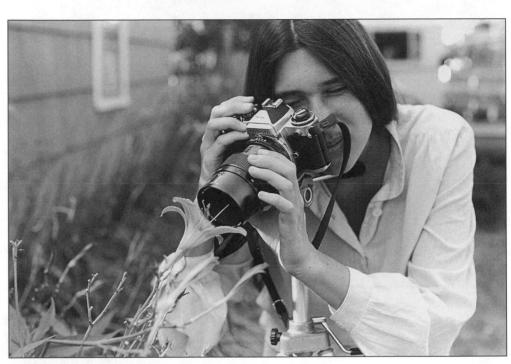

130

Another type of lens is a macro lens. A macro lens can focus to within a few inches from the lens itself (this depends on the brand and model of macro lens). The advantage of a macro is that it is easy to use and fast to set up and focus.

131

Many times when you take a photograph you want to know its depth of field so you can determine the proper exposure combination. There are several ways of checking depth of field. One way is using the depth of field scale on the camera's lens. To use the scale, focus the lens on your subject.

132

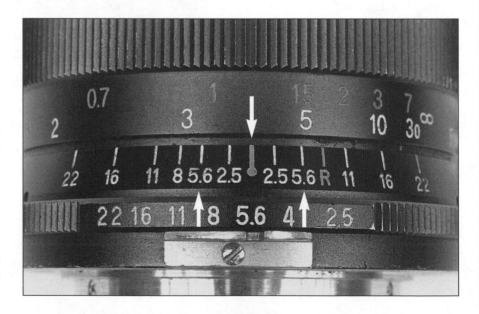

Now look on the distance indicator on the lens (top arrow), it indicates 4 feet. Look on the right and left of the line marker and you will see the f-stops marked.

The f-stop selected on the aperture ring is f/5.6. On the depth of field scale line up 5.6 on both sides (lower arrows) with the distance numbers. The numbers show that from 3 1/2 to 5 feet is the depth of field. Everything within that distance will be in focus.

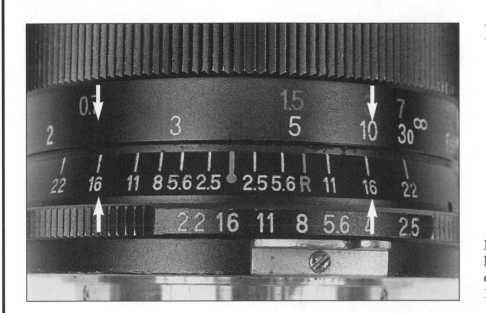

133

If f/16 was the aperture selected, you would line up f/16 on both sides (arrows) with the distance scale. This would indicate that 2 1/2 to 10 feet is in focus.

134

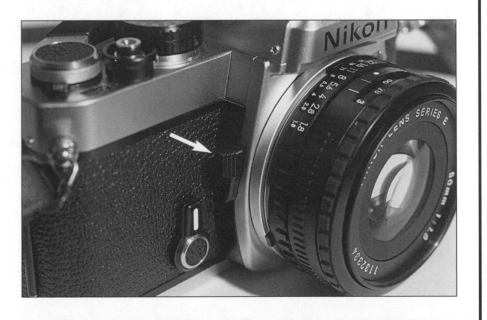

Many cameras such as this one, have a depth of field preview button (arrow). When you press the button, the aperture closes down to the selected f-stop. You can see in the viewfinder the distance that is in focus: the depth of field.

depth of field preview

Lens and Camera Care

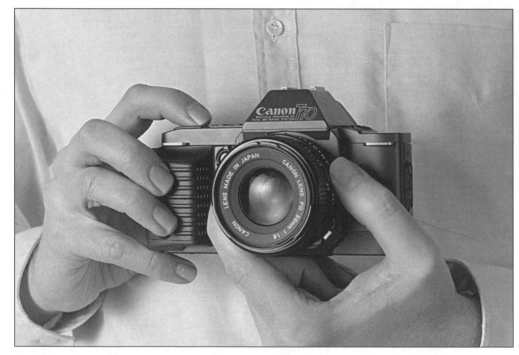

135

It is important to keep your lenses clean. Dust, grease, and moisture all affect light and soften the sharpness of your photographs.

10

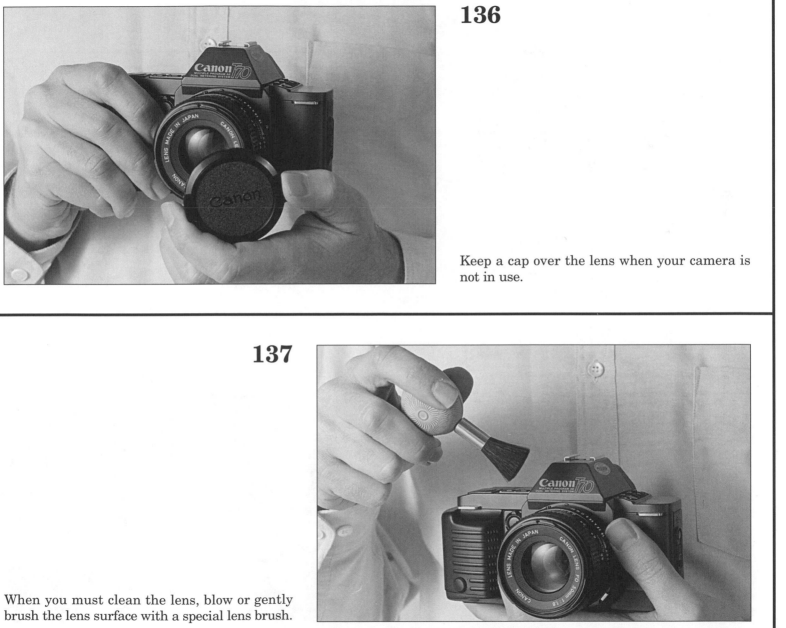

136

Keep a cap over the lens when your camera is not in use.

137

When you must clean the lens, blow or gently brush the lens surface with a special lens brush.

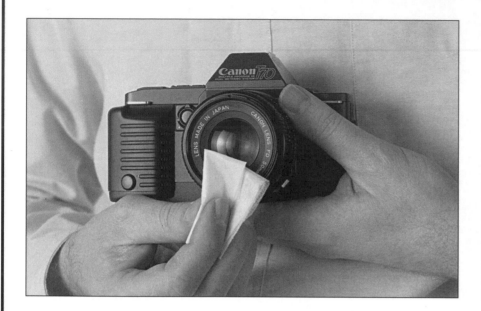

138

A special camera lens tissue can also be used to clean the camera lens.

The lens surface is very delicate and is easily scratched. Don't clean your lens unless necessary. If you clean it too often it's possible you could put in fine scratches or rub away the lens coating.

Many photographers use a sky-light or UV filter on the lens. In addition to filtering light, the filter will keep dust away and protect the lens.

139

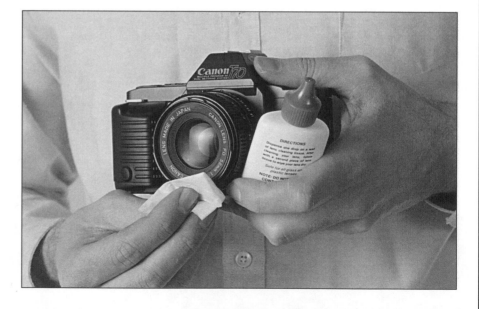

To clean grease or other spots, put several drops of lens cleaner solution on a special lens tissue and wipe the lens gently.

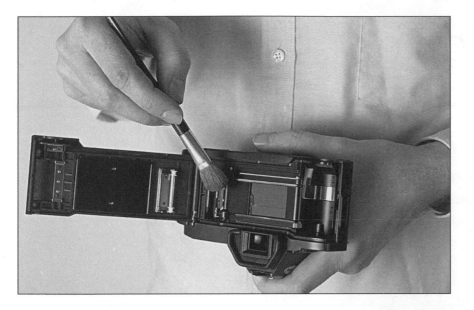

140

It's also important to keep the inside of your camera as clean as possible. Dust and film particles can scratch your film and get into the camera mechanism.

After every roll of film gently clean the inside of the camera with a clean soft brush. Be careful not to touch the shutter. It is very delicate and can be damaged easily.

141

It is recommended you have a good case and shoulder strap for your camera. When you are not taking photos keep your camera protected in its case.

Lens Accessories

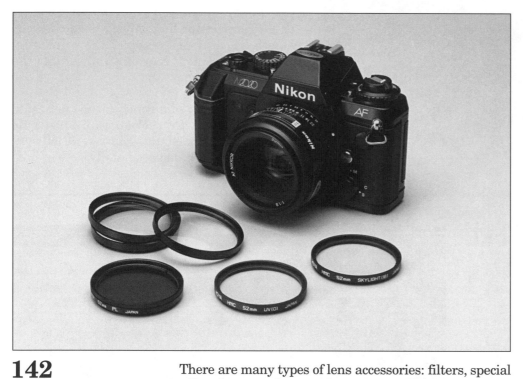

11

142 There are many types of lens accessories: filters, special effect lenses, close-up lenses, etc. We will discuss several of the most common. Most of these accessories screw on to the front of the lens and are available in various diameters depending on the lens size.

143

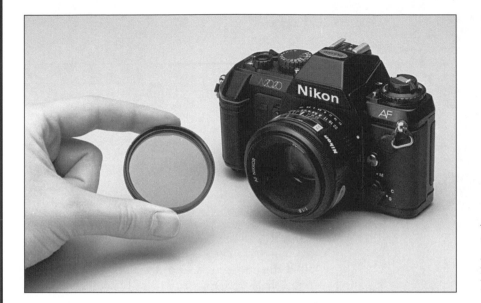

A polarizing filter can be used to reduce or eliminate reflections if you are photographing glass, water, or smooth surfaces. A polarizing filter can also make colors more vivid and landscapes sharper and clearer.

144

A sky-light can be used that reduces haze and slightly increases the contrast of photographs. As mentioned earlier, many photographers keep a sky-light filter on their lens nearly all the time. It protects against dirt and possible damage.

145

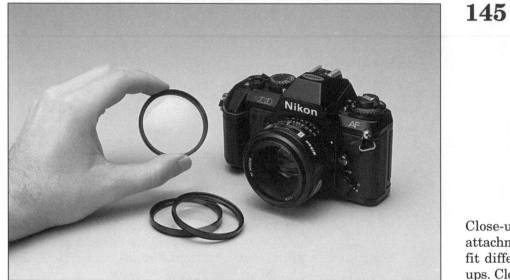

Close-up lenses are another type of lens attachment. They come in various diameters to fit different lenses and are used to take close ups. Close-up lenses are usually sold in sets.

146

Each lens is numbered. The bigger the number lens you use, the closer you can get to your subject.

Flash Photography

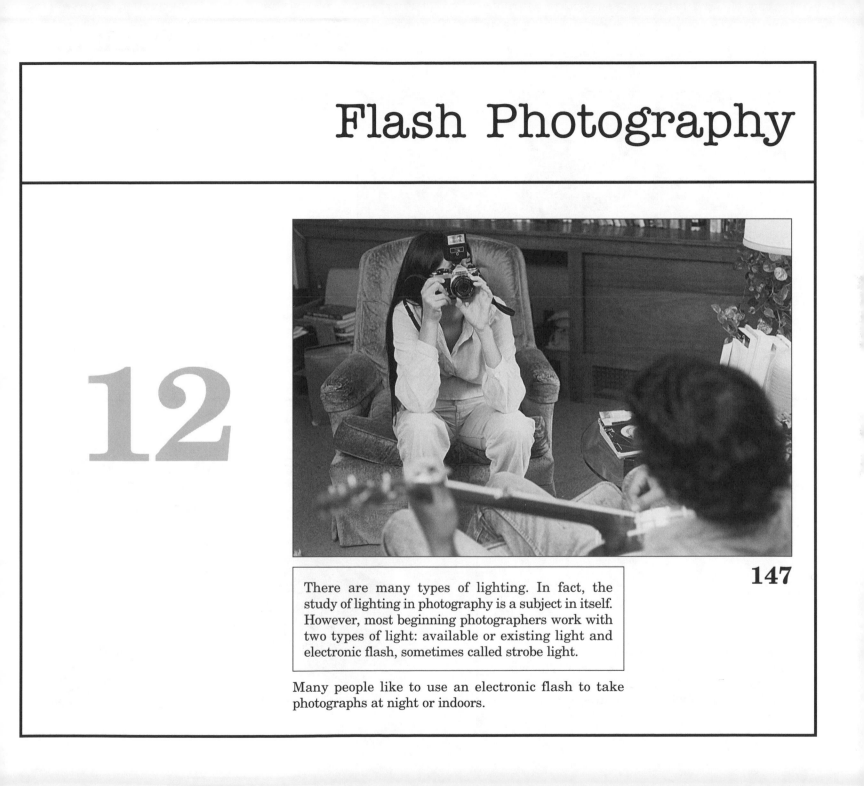

There are many types of lighting. In fact, the study of lighting in photography is a subject in itself. However, most beginning photographers work with two types of light: available or existing light and electronic flash, sometimes called strobe light.

Many people like to use an electronic flash to take photographs at night or indoors.

148

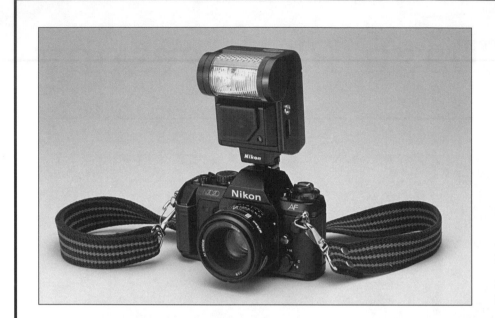

Electronic flashes operate on batteries and can be re-used repeatedly; no bulbs need to be replaced after each shot. Many cameras have a flash shoe to hold the flash unit when in use.

149

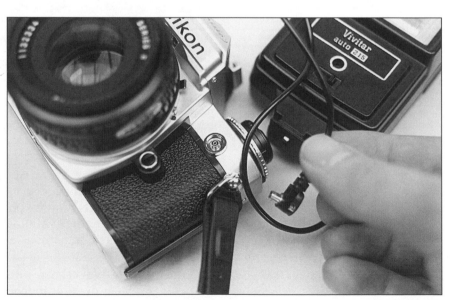

Most cameras have a standard X socket for plugging the flash into the camera. The wire synchronizes the flash unit with the camera so the flash goes off when the shutter is open.

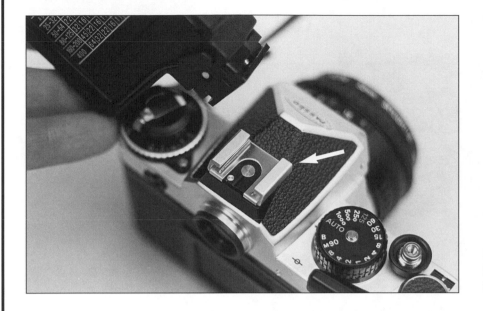

150

Other cameras have a "hot shoe" (arrow) that is internally wired so a cord is not needed to synchronize the flash with the camera.

151

The shutter speed must be set on the camera's strobe setting when using an electronic flash. On this camera, the strobe setting is 1/125 sec. The strobe setting varies depending on the type of camera you have. If you were to set a faster shutter speed than the strobe setting, the shutter would be open part way when the exposure is made. This would expose only a small section of the photograph (some rangefinder 35mm cameras function differently — refer to instruction manual).

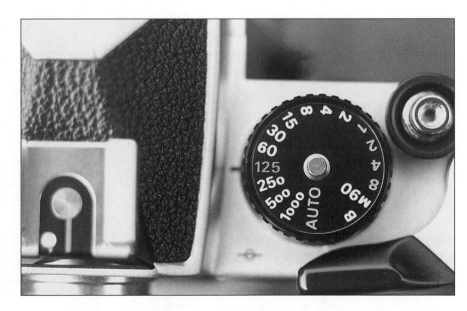

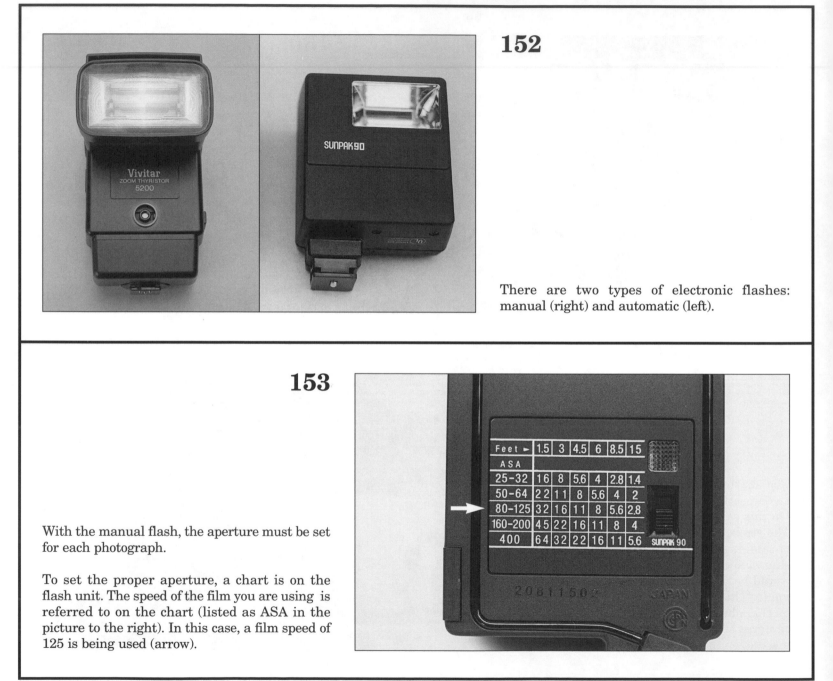

152

There are two types of electronic flashes: manual (right) and automatic (left).

153

Feet ►	1.5	3	4.5	6	8.5	15
ASA						
25-32	16	8	5.6	4	2.8	1.4
50-64	22	11	8	5.6	4	2
80-125	32	16	11	8	5.6	2.8
160-200	45	22	16	11	8	4
400	64	32	22	16	11	5.6

SUNPAK 90

With the manual flash, the aperture must be set for each photograph.

To set the proper aperture, a chart is on the flash unit. The speed of the film you are using is referred to on the chart (listed as ASA in the picture to the right). In this case, a film speed of 125 is being used (arrow).

154

Focus on your subject. Then check the focusing distance on the lens barrel. In this case the camera is 9 feet away.

155

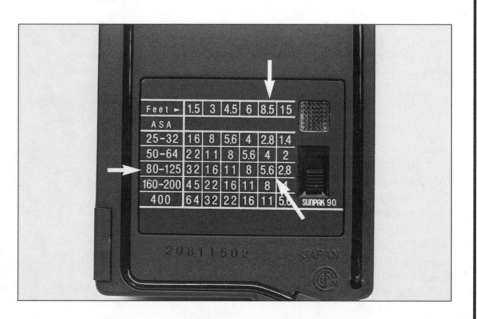

Feet ►	1.5	3	4.5	6	8.5	15
ASA						
25-32	16	8	5.6	4	2.8	1.4
50-64	22	11	8	5.6	4	2
80-125	32	16	11	8	5.6	2.8
160-200	45	22	16	11	8	4
400	64	32	22	16	11	5.6

SUNPAK 90

20811602 JAPAN

Now look at the chart. Line up the film speed of 125 (listed as ASA in the picture to the right) and 9 feet. The chart indicates that at that distance the f-stop should be f/5.6

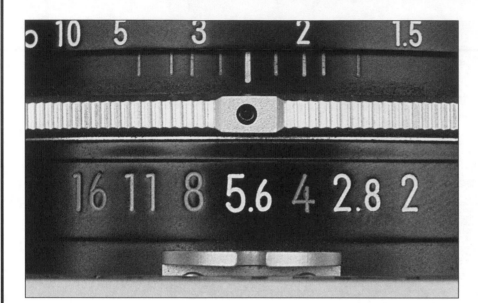

156

F/5.6 is set on the camera's lens. You are now ready to take a flash picture. Of course, each time the distance changes you must refer again to the chart and re-adjust the f-stop.

The shutter speed does not change, it remains the same at the strobe setting.

157

With the automatic electronic flash the aperture does not have to be re-set for each photograph. The aperture is set on one f-stop and the flash unit automatically adjusts the needed amount of light emitted. You don't have to refer to a chart to set the f-stop each time. The aperture you use depends on the model flash you have and the film speed you are using. Refer to the instructions with your flash unit.

automatic flash

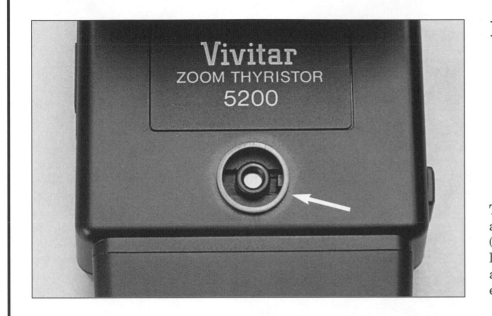

158

The flash unit's light is adjusted to the proper amount by a sensor built into the flash unit (arrow). The sensor measures the amount of light reflected from the subject and automatically shuts off the flash at the proper exposure.

159

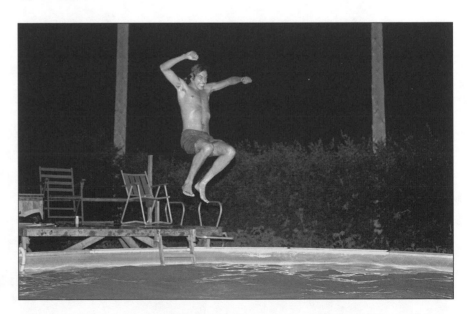

Electronic flash units are great for action shots and portrait lighting. The flash of light is so fast (1/1000 sec. or shorter) it freezes moving subjects, providing a photograph with a clear unblurred image even though the shutter speed is relatively slow.

160

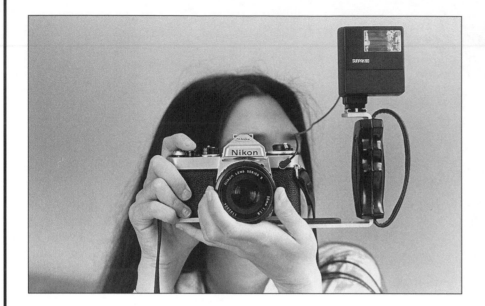

A few flash cautions. If the flash unit is close to the lens and the subject is looking straight at the camera you may find the eyes will appear reddish in a color photo. The effect can be prevented by having your subject look slightly to one side or by mounting the flash unit to the side away from the lens. A bracket can be used for this purpose.

161

If your subject wears eyeglasses, reflection with the flash can be a problem. This can be prevented if you have your subject hold his head slightly to one side.

162

Flash units can also produce reflection from shiny backgrounds like windows and mirrors.

163

You can avoid these reflections by shooting at an angle to the window.

164

Some flash units have adjustable heads that allow the photographer to bounce light from the ceiling or wall. This diffuses the light that illuminates your subject and makes that light less harsh and more natural.

164b

Dedicated flash units for automatic cameras are designed to automatically set the shutter speed to the proper strobe setting (flash synchronization). Many of the flash units also have other features such as aperture setting, correct exposure indication, and recycling indication. With a dedicated flash, camera exposure can be totally automatic.

dedicated flash

13

Available light is whatever illumination is present without the use of a flash or extra lights. Let's take a look at several forms of available light so you will be able to predict where you will find these light qualities when you take your photos.

This photograph was illuminated entirely by candle light.

165

166

Direct light is bright light that comes from the sun on clear days. Direct light produces bright highlights and dark shadows with dark edges. Since direct light is very intense, most photographers have to reduce the light by speeding up the camera's shutter or using a small aperture or both.

167

Direct/diffused light is direct light that has been diffused. It's shadows are distinct but soft and not as dark as in direct light. Colors are bright and accurately rendered. This light is usually produced on a moderately overcast day or in open shaded areas. Direct/diffused light sometimes appears indoors where light is reflected in through a skylight or windows.

168

Diffused light is soft, low in contrast light. It comes from overcast skies or is light that has been diffused by inside walls or a screen. Diffused light illuminates all parts of a scene and produces weak shadows that are excellent for portrait lighting.

169

This photograph has a strong backlight coming in through the window. The camera's meter measured the outside backlight and the result was a silhouetted subject.

170

This is the photo after the aperture was opened up an extra two f-stops to allow for more light. It was exposed for the subject and over-exposed for the outside. If you find yourself taking a backlight photo: move in close to the important part of the scene; aim your camera and take an exposure reading from the subject, not including the background; then re-compose your photo. Many of the automatic 35mm cameras have a special backlight switch that adjust the exposure for backlighting.

Composition—the rules?

14

171

Good composition comes through experience and a creative eye. Composition rules can be helpful in guiding a beginning photographer. However, we should note that no rule has to be observed. In fact, some of the best photographs have broken "the rules."

172

CAMERA ANGLE — Many beginning photographers take all their photos from eye level. This results in a repetitive and boring point of view. As we mentioned earlier, experiment and shoot photos from different levels, angles, and points of view.

173

As shown by these two photos, shooting up or down on a subject can have a visual effect on the viewer by making a subject appear more interesting or by emphasizing a subject's features.

174

GET UP CLOSE! Most beginners tend to shoot too far away from their subject.

175

It's important to get up close to your subject and remove unwanted details. This adds impact to your shots.

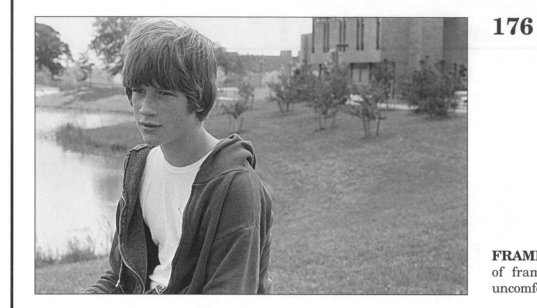

176

FRAMING BALANCE — A person moving out of frame sometimes makes the viewer feel uncomfortable.

177

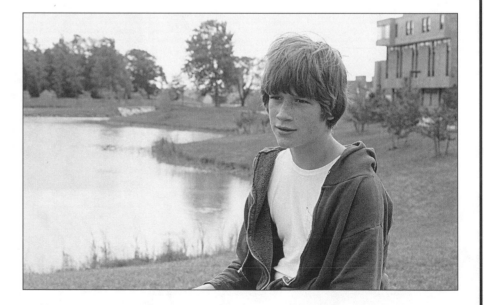

Facing your subject into space within the frame makes for a more pleasing and balanced composition.

178

FRAMING SCENES — A frame such as a tree branch or window can enhance the composition of photograph. It helps direct the viewer's attention to the main subject and contains action in the frame. Frames also help to create a feeling of depth and add interest to a photograph.

for Beginning Photographers

1. **Hold your camera steady and squeeze the shutter release** — This is important in order to get sharp and unblurred photographs. Whenever possible use a tripod!

2. **Get up close to your subject!** Most beginners shoot too far away. Move in close to your subject and add impact to your photographs.

3. **Load the film carefully!** Many beginning photographers have lost important photos because they loaded improperly and the film never went through the camera. Remember the rewind!

4. **Experiment with composition** — Creative composition can add excitement and interest to your photographs. By experimenting with angles, framing and balance you can discover unique and innovative composition.

5. **Try different types of film** — Selecting a film for your needs comes from experimenting with different types. Each type has its unique grain, contrast and color qualities.

6. **Keep your camera and lens clean** — Dust, grease, and moisture on the lens can affect light and soften the sharpness of your photos. Dust and film particles inside your camera can scratch your film and get into the camera mechanism.

Index

INDEX — Basic 35mm Photo Guide

aperture, 6, 84-94, 100
aperture priority, 117-118
aperture/shutter priority, 117, 120
ASA, 31, 109, 153, 155
automatic cameras, 67, 117-120
automatic flash, 152, 157-158
automatic focusing, 72
available light, 147, 165
backlight, 169-170
basic exposure, 95-105
batteries, 8
bounce flash, 164
built-in light meter, 96, 106-115, 117
B setting, 76
cable release, 23
camera adjustments, 66
camera angles, 172-173
camera case, 141
camera cleaning, 140
camera parts, 6-9, 49-50
camera shake, 10
close up lens, 142, 145-146
close ups, 174-175
color film, 38-42
color film, daylight, 42
color film tungsten, 42
color print film, 39
color slide film, 40-41
compact, 2, 35
composition, 171-178
dedicated flash, 164

depth of field, 90-94, 101-105, 114, 116, 131-132
depth of field preview, 133-134
depth of field scale, 131
diffused light, 168
direct/diffused light, 167
direct light, 166
DX coding, 60
Ektachrome film, 38, 41, 42, 44
electronic flash, 147-164
emulsion, 25-26
eyeglasses, 14, 161
exposure control, 73-89
fast or high speed film, 29, 32
film, 24-47
film advance lever, 7, 55, 59
film counter, 58
film lengths, 24
film loading, 48-65
film pressure plate, 9
film rewind, 6, 8, 61-65
film speed, 28-38, 44, 109, 153, 155
film storage, 46-47
film unloading, 48-65
filters, 142-144
flash cautions, 160-163
flash units, 147-164
focal length, 121-129
focusing, 68-72
FP 4, 34
framing balance, 176-177
framing scenes, 178

Index

f-stop, 84-94, 100
grain, 29-30, 45
grid focusing, 71
hand held light meter, 96-105
hand holding, 10-18
high speed film, 29
holding your camera, 10-18
HP 5, 32
iris, 84
ISO, 31, 109
Kodachrome, 28, 45
Kodacolor, 41, 44
latent image, 26
lens and camera care, 135-141
lens cap, 136
lens cleaning, 137-139
lenses, 121, 133
lens filters, 142-144
lens-shutter, 2
lighting, 147-170
loading and unloading your camera, 48-65
low speed or slow film, 28, 36
macro lens, 130
manual flash, 130
multi-program, 120b
negative film, 27, 38
normal lens, 122
Pan F, 28, 36
Plus-X, 34-35, 45
polarizing filter, 143

portraits, 159
program, 120b
rangefinder 35mm, 2, 72
rewind button, 62-63
rewind crank, 49, 51, 64
royal gold, 29, 36
selecting a film, 43-45
semi-automatic cameras, 66, 106-116
shutter, 6, 9
shutter priority, 117, 119
shutter speed, 75-83, 101-105, 110-111, 115, 152, 159
shutter speed selector, 6
single lens reflex, 2-9
sky-light filter, 144
slide film, 27
slow film, 28
SLR, 2-9
split image viewfinder, 70
storing film, 46-47
telephoto lens, 108, 126-128
tele program, 120b
T-grain, 47b
tripod, 19-23
Tri-X, 32, 44
vertical photos, 13
viewfinder, 2-4, 7, 69, 112-113
wide-angle lens, 123-125
wide program, 120b
X-socket, 149-150
zoom lens, 129

Other Books from Amherst Media, Inc.

Basic 35mm Photo Guide
Craig Alesse

Great for beginning photographers! Designed to teach 35mm basics step-by-step — completely illustrated. Features the latest cameras as well as the classic models. Includes: 35mm automatic and semi-automatic cameras, camera handling, f-stops, shutter speeds, and more! $12.95 list, 9 x 8, 112 p, 178 photos, order no. 1051.

Infrared Photography Handbook
Laurie White

Totally covers black and white infrared photography: focus, lenses, film loading, film speed rating, heat sensitivity, batch testing, paper stocks, and filters. Black & white photos illustrate how IR film reacts in portrait, landscape, and architectural photography. $24.95 list, 8 1/2 x 11, 104 p, 50 B&W photos, charts & diagrams, order no. 1419.

Wedding Photographer's Handbook
Robert and Sheila Hurth

The complete step-by-step guide to photographing weddings – everything you need to start and succeed in the exciting and profitable world of wedding photography. Packed with shooting tips, equipment lists, must-get photo lists, business strategies, and much more! $24.95 list, 8 1/2 x 11, 176 p, index, b&w and color photos, diagrams, order no. 1485.

Lighting for People Photography
Stephen Crain

The complete guide to lighting and its different qualities. Includes: set-ups, equipment information, how to control strobe and natural lighting, and much more! Features diagrams, illustrations, and exercises for practicing the lighting techniques discussed in each chapter. $24.95 list, 8 1/2 x 11, 112 p, b&w and color photos, glossary, index, order no. 1296.

Wide-Angle Lens Photography
Joseph Paduano

For everyone with a wide-angle lens or people who want one! Includes taking exciting travel photos, creating wild special effects, using distortion for powerful images, and much more! Part of the Amherst Media's Photo-Imaging Series. $15.95 list, 7 x 10, 112 p, glossary, index, appendices, b&w and color photos, order no. 1480.

Zoom Lens Photography
Raymond Bial

Get to know the most versatile lens in the world! Includes how to take vacation, landscape, still life, sports and other photos. Features product information, accessories, shooting tips, and more! Part of the Amherst Media's Photo-Imaging Series. $15.95 list, 7 x 10, 112 p, b&w and color photos, index, glossary, appendices, order no. 1493.

Big Bucks Selling Your Photography
Cliff Hollenbeck

A complete photo business package for all photographers. Includes secrets to making big bucks, starting up, getting paid the right price, and creating successful portfolios! Features setting financial, marketing and creative goals. This book will help to organize business planning, bookkeeping, and taxes. $15.95 list, 6x9, 336 p, Hollenbeck, order no. 1177

McBroom's Camera Bluebook
Mike McBroom

Comprehensive, fully illustrated, with price information on: 35mm cameras, medium & large format cameras, exposure meters, strobes and accessories. Pricing info based on equipment condition. Designed for quick and easy reference. A must-have book for any camera buyer, dealer, or collector! $29.95 list, 8x11, 224 p, 75+ photos, order no. 1263.

Camera Maintenance & Repair
Thomas Tomosy

A step-by-step, fully illustrated guide by a master camera repair technician. Sections include: testing camera functions, general maintenance, basic tools needed and where to get them, basic repairs for accessories, camera electronics, plus "quick tips" for maintenance and repair of specific models! $24.95 list, 8 1/2 x 11, 176 p, order no. 1158.

Great Travel Photography
Cliff and Nancy Hollenbeck

Learn how to capture great travel photos from the Travel Photographer of the Year! Includes helpful travel and safety tips, packing and equipment checklists, and much more!Includes beautiful photographic examples from all over the world! Part of the Amherst Media's Photo-Imaging Series. $15.95 list, 7 x 10, 112 p, b&w and color photos, index, glossary, appendices, order no. 1494.

Build Your Own Home Darkroom
Lista Duren & Will McDonald

This classic book shows how to build a high quality, inexpensive darkroom in your basement, spare room, or almost anywhere. Information on: darkroom design, woodworking, tools, and more! $17.95 list, 8 1/2 x 11, 160 p, order no. 1092.

Into Your Darkroom Step-by-Step
Dennis P. Curtin

The ideal beginning darkroom guide. Easy to follow and fully illustrated each step of the way. Information on: equipment you'll need, set-up, making proof sheets and much more! $17.95 list, 8 1.2 x 11. 90 p, hundreds of photos, order no. 1093.

More Photo Books Are Available

Write or fax for a *FREE* catalog:
Amherst Media, Inc.
PO Box 586
Buffalo, NY 14226 USA

Fax: 716-874-4508